The
Basic Law
Of Color Theory

About the Author

Harald Kueppers, born in 1928, learned reproduction technology from the bottom up. He earned his master's degree in color reproduction and completed engineering studies at the Higher Technical School for the Printing Industry in Stuttgart in 1958. He is the managing partner of a reproduction company, and is also an active lecturer in the specialized field of color theory. He is a member of various German standardization committees concerned with color, and is, as a board member of the German Color Center Membership Corporation, responsible for color theory and communication technologies. He has become well known through his numerous articles in periodicals and his books, *Farbe—Ursprung, Systematik, Anwendung [Color: Origins, Systems, Uses]* and *Die Logik der Farbe: Theoretische Grundlagen der Farbenlehre [The Logic of Color: Theoretical Principles of Color Theory]* (both published in Munich). Kueppers presented his new color theory to a wide public on the German television program, "From Research and Technology." Barron's has also published his *Color Atlas: A Practical Guide to Color Mixing.*

Harald Kueppers

The
Basic Law
of Color Theory

Translator: Roger Marcinik

Woodbury, New York • London • Toronto • Sydney

First U.S. edition published in 1982 by Barron's Educational Series, Inc.

© Copyright 1978 by DuMont Buchverlag GmbH & Co.
© Copyright 1980 by DuMont Buchverlag GmbH & Co.

All rights for all countries reserved by DuMont Buchverlag GmbH & Co., Kommanditgesellschaft, Cologne, West Germany.
The title of the German edition is:

DAS GRUNDGESETZ DER FARBENLEHRE
by Harald Küppers [Kueppers]

All inquiries should be addressed to:
Barron's Educational Series, Inc.
113 Crossways Park Drive
Woodbury, New York 11797

Library of Congress Catalog Card No. 81-17628
International Standard Book No. 0-8120-2173-8

Library of Congress Cataloging in Publication Data
Kueppers, Harald.
 The basic law of color theory.

 Translation of: Das Grundgesetz der Farbenlehre.
 Bibliography: p.
 1. Colors. 2. Color in art. I. Title.
ND1492.K8313 535.6 81-17628
ISBN 0-8120-2173-8 AACR2

PRINTED IN HONG KONG
345 490 9876543

Contents

Note: Photo captions for color figures may be found on page 144.

Preface to Second Edition

When a second edition of his book is printed, the author may well be pleased. Especially since, in the meantime, the book has been published in English and Spanish. Such response shows that it was meaningful to compile this practical and instructive conception of color theory that is easy to understand.

The book was readily accepted, especially by teachers and art educators, as I was able to observe in the first teacher training seminars that I conducted on this subject. Again and again, however, the question was asked: "Where can we teachers get the instructional aids that we need in the classes?"

This question is legitimate. It is too much to expect each teacher to make his own aids, namely charts and models, himself. However, these aids are an important means of demonstration that help the student to learn, for they require him to personally handle color, which is imperative. Through systematic mixing exercises, the student can come to know and even positively "experience" how color conforms to laws. He acquires, moreover, an orientation to and understanding of the diversity of color and can actually create with exactness the hues he has imagined by mixing them himself.

In the meantime, therefore, I have compiled a list of the most important teaching aids (see Supply Sources): color charts on large posters [Z 1]; a model that explains the functioning of the three major color mixing laws (additive, subtractive, and integrated mixing) and demonstrates the connections between them [Z 2]; a set of eight harmonized basic colors that are available as artist gouache (tempera) paints [Z 3]; and finally a comprehensive color mixing course in the form of a coloring book for working with this new basic color set [Z 4].

Perhaps these new aids can contribute to color theory getting the place it deserves in the curricula—one that corresponds to its importance.

Preface to First Edition

About 80% of all of the information that an individual normally receives is of an optical nature. This pertains, of course, not only to reading newspapers, magazines, and books and looking at the illustrations they contain; we also view slides, movies, and television.

The significance of visual information, however, is considerably more comprehensive than the examples mentioned here might lead us to assume. Whenever an individual is awake and his eyes are open, there is no letup in the onrush of a continual sequence of optical information coming toward him. A housewife might be preparing supper; a husband might be on the job; children might be playing ping-pong; or the whole family might be out for a ride through the countryside. The eye is constantly flooded with visual impressions.

Optical data give us information about shapes, on the one hand, and colors, on the other hand. Who would venture an opinion as to which of the two is more important? It certainly varies from one case to the next. A doctor frequently makes his diagnosis according to the color of an organ. A spoiled or unripe fruit can be distinguished from a ripe one in many cases by its color alone. Traffic signs become clearly visible only through their color.

Dresses or suits may be absolutely equal in style. The purchasing decision here depends on the color—as often happens, for example, in connection with carpets, drapes, wallpaper, etc., as well. Indeed, it has also happened that a construction contractor, when faced with offers submitted by different suppliers that may be roughly equivalent in terms of engineering and price, picked the yellow dredger because he liked the color better.

Because visual data fundamentally consist simultaneously of shape data and color data (achromatic colors in a black-and-white picture are also colors), one can assume, estimating very roughly, that 40% of all of the information that an individual normally receives consists of information about color. Although we have not touched on the esthetic and psychological aspects so far, these figures clearly show the significance that color has, or should have, in peoples' lives.

How strange it seems to us that most people know almost nothing about color, in spite of its significance as a source of information, on the one hand, and as a means of esthetic expression, on the other

hand. We may have learned about the spectrum in school and we may have heard something about spectral analysis. The color circle was probably also discussed. In physics books we occasionally find references to the laws of color mixing, which frequently, however, are not understood because the explanations are usually not in any logical interconnection and because a definition of color names and color terms is always lacking.

Knowledge of the basic laws of color theory should be a natural component of general education. This requirement undoubtedly will be fully approved by anyone who is aware of the above-described significance of color in our lives. But we must note to our astonishment that color theory, in the sense described here, is not only missing from the curricula of most elementary and high schools; even in the curricula of colleges and technical schools it can only be found in very rare cases.

This, of course, is no coincidence; there are reasons for it. The main reason probably resides in the fact that color is not something constant and objectively graspable. This is because, basically, color is nothing but a sensation in the observer's sensory system. But that is not all: material colors, called "object colors" or "surface colors" in technical terminology, are subjected to constant changes. They change in terms of their appearance as a function of the existing light and as a function of the particular observation situation. This is because the visual system possesses an astonishing adaptability to different illumination and observation circumstances.

Because perceptions cannot be measured, the scientific method is to refer to the so-called "color stimulus." By this we mean light rays that strike the eye and have the function of transmitting information. As everyone knows, radiation technology is an aspect of physics. Physicists who are concerned with visible energy rays (which we call light or color stimulus) are specialists who are generally referred to as light technicians or colorimetricians. Naturally, in their special field, they deal with "color" in their own fashion. But they are not justified in considering themselves to be *the* "color scientists" as such. Color science can only be a whole. And that adds up to much more than light technology and colorimetry. That adds up to "color theory." This misconception obviously requires clarification.

Thus it is the purpose of this book to present a generally valid and understandable color theory based on scientifically supported facts. The title of this book would lead the reader to expect to find a color

theory applicable to all disciplines and all areas of application of color. The statements in this book will show that this is indeed the case. This is because color is not a physical phenomenon; instead, it is a physiological one. Color is exclusively color sensation. This is why the basic law of color theory is the law according to which the human visual system functions. All forms of color origin, mixing, and perception can and must be explained by this higher principle.

To understand this, we must begin with the human visual system. Its functional principle gives us information about the interrelated factors. What we encounter as simultaneous contrast, as adaptation capability, or as afterimage colors, is nothing but a series of references to this functional principle. The various "color mixing laws" are possibilities for the interpretation of the visual system's operating procedure. Anyone who has understood this functional principle has also understood the basic law of color theory.

The geometrical arrangement of all hues (all of the sensations that the visual system can produce) is very clearly illustrated by the rhombohedron color space (color fig. 10). The way the visual system performs is convincingly represented by the "model for the explanation of sensation origin in the human visual system" (color fig. 9). In the final analysis, all other facts refer to these two models because physics, in the interaction between light emission and color perception, merely has the task of information transmission. Rays are not colors; instead, they cause the visual system to produce color sensations.

Now we should also go into the interesting and controversial question: does an artist, a color designer, really need a color theory?

As we know, there are determined advocates and opponents of color theory. Its opponents cite their intuition. For them, artistic creation is an emotional action and they reject any color theory as a disturbance of their emotionally determined activity.

Its advocates, on the other hand, are of the opinion that intuition is not a sufficient foundation. Instead, they are convinced that only the combination of solid knowledge of the subject with intelligence and intuition can open up the entire arsenal of possibilities given by color.

Of course, even a shepherd boy on a mountain can make outstanding music with a homemade flute; today we might perhaps call this "naive music." Undoubtedly, such music would have its special charms as compared to the slick tones and ditties with which

we are flooded in the media. But in all probability we are not going to get Beethoven or Haydn out of our shepherd boy. Can we not also transpose this example to the art of color application?

In the year 1452, in a little village by the name of Vinci, a baby was born whom his parents named Leonardo; he was to become one of the most famous and important artists in the world, Leonardo da Vinci. His talent was outstanding and many-sided. Among many others, Leonardo wrote a work entitled *Treatise on Painting*, in which we find the following passage:

> *On the error of those who practice without science.*
> Those who fall in love with practice without science are like pilots who board a ship without rudder or compass, who are never certain where they are going.
> Practice ought always to be built on sound theory. . . .*

Is there anything to be added to Leonardo's opinion on the question as to whether an artist needs a color theory? And doesn't what was said regarding the application of color in art and design apply equally to all areas of industrial color utilization, color psychology, and, last but not least, to the entire paint producing industry?

*A. P. McMahon, *Treatise on Painting by Leonardo da Vinci* (Princeton: Princeton University Press, 1956), Vol. I, page 48.

Introduction to English Language Edition

Color theory is a fascinating subject surely not only for scientists, engineers, designers, and artists who deal with color professionally, but for every interested person; for sight is the most important of the senses. And color as a part of sight is an essential factor in man's world of experience. The average person, however, knows little or nothing about the underlying laws governing color, probably for the simple reason that it could not be taught to him. For until now a color theory that is universally valid and at the same time intelligible to all has been lacking. Until now there have been really only "branch theories" from physicists, colorimetrists, physiologists, psychologists, chemists, engineers, artists, designers, etc.

Convinced that there must be a single truth, a higher law hidden behind all these partial theories, I began my research a decade and a half ago. This led me to the view that all of the apparently different color mixing laws should be explained by the same principle: by the function of the human visual system. From this point of view additive color mixture (color television) as well as subtractive color mixture (color photography) can be precisely explained. Hence, the mixing qualities of an opaque material become just as intelligible as those of a transparent one.

To reach a clear and easily understandable educational conception, references to academic discussions and historical facts have been omitted in this book. This is not the place for them, and they would only confuse the reader. Historical connections are presented in my book *Farbe—Ursprung, Systematik, Anwendung* (Munich: Callwey, 1977), 3rd edition [*Color: Origin, System, Uses* (New York: Van Nostrand Reinhold, 1973)]. The detailed scientific and mathematical substantiation for my new theory is presented in my book *Die Logik der Farbe. Die theoretischen Grundlagen der Farbenlehre* [*The Logic of Color: The Theoretical Principles of Color Theory*] (Munich: Callwey, 1976). The scope of the present volume is to offer a teaching and learning system that will make it possible for color theory to become a part of general education.

Certainly, difficult problems had to be solved. These problems are surely not related to the logic of the connections, but much more to the linguistic presentation. For traditional color names and color terms prove in part to be unsuited for making the connections

unequivocally clear to the reader. This has held true, moreover, not only for German, but also for English in the same way.

For when, for example, Fred W. Billmeyer or Günter Wyszecki say "blue," they mean a color called "violet" by Faber Birren or Walter Sargent. What is "magenta" to them is "purple" or "red" to others, and what is "red" to them is "orange" to others.

Albert H. Munsell calls the quality characteristics of a color "hue, chroma, and value." Ralph M. Evans by comparison speaks of "hue, saturation, and brightness." Finally, at the international conference of the AIC (Association Internationale de la Couleur [International Color Association]) in Troy in 1977, R. W. G. Hunt proposed introducing the term "colorfulness" to replace "saturation." This is an unacceptable proposal because, after all, white and black are also colors, namely achromatic colors.

These few examples should illustrate the linguistic dilemma faced by the author, the translator, and the editor. For it proved to be impossible to retain established names and terms in order to be precisely understood by the reader. Consequently, new unequivocal and unmistakable names and terms had to be found. For it seems out of the question to use existing terms only to provide them with new meanings.

For the accomplishment of such a difficult translation task, I have to especially thank Mr. Roger Marcinik. But I am also indebted to Mr. Gerhard Popp, who contributed significantly to the solution of the linguistic problems by his help in translating my article, "Let's Say Goodbye to the Color Circle," in *Color Research and Application* (New York: John Wiley & Sons, Inc., Spring 1979, Vol. 4, No. 1, pp. 19-24). I also wish to thank Mr. Fred W. Wentzel, who was a consultant on the translation, and, last but not least, the editor of the English version, Ms. Ruth Pecan.

Presumably, the publication of this book in America will evoke a response similar to that which has occurred in Germany. There will be enthusiastic supporters, because a logical integrated presentation of the special subject of color theory that is intelligible to everyone and reasonably priced in the bargain is finally available. There will, however, also be bitter opponents, namely the "expert" physicists, who will reproach me, alleging that I have broken away from scientific usage with regard to color names and color terms and am therefore responsible for adding to the existing confusion. They will say that their views should have been endorsed. Finally, the colorimetrists will presumably reproach me, alleging that I have

made impermissible simplifications and inaccuracies. But there will be no precise, objective arguments; for my theory is based on the solid scientific knowledge of our time. Only my thoughts lead me to a different, unconventional conclusion—to the conclusion, namely, that color does not exist at all in the physical world. Consequently, it makes no sense to seek its basic law in physics.

An important book by the Optical Society of America, *The Science of Color,* was published in the United States in 1953. Without a doubt, this book represents the "truth" about color even to this very day; not the whole truth, however, but only a part of it. Printed in red on the jacket is the subtitle "The definitive book on color." This was certainly a bold claim, for as is well known, definitive solutions are quite rare in science. It would be pointless to pose the question of whether the new theory presented here is now definitive. That decision can confidently be left to the future.

The modest aim of this book is to be really understood by the reader.

What Is Color?

§ 1 Interference Colors from Achromatic Material

Color is by no means the property of material to show its colorful appearance.

An object or a piece of material has a certain color, in addition to a certain shape and size. One is inclined to assume that this color belongs to the particular material in a manner comparable to its properties of shape and size. But that would be an error; we are dealing with an illusion here. Color only *seems* to be a material property. In reality, however, it exists exclusively as a sensory perception on the part of the viewer.

Demonstration:
Overhead projector
Two polarization support films, at least 9 x 12 cm each [A]*
One sheet of cellophane (hard grade)

Place a polarization film on the transparent surface of the overhead projector. Now crumple the cellophane sheet or place strips of it irregularly, crosswise, in each case, on the polarization film underneath. If you now place the second polarization film on top of that, you can perceive luminous variegated colors (color fig. 1). By turning the upper filter, you can change the colors. The same spot can change color from yellow to green and finally become blue, violet, and red until it again looks yellow, when the same rotation angle of the upper filter is again reached.

*The letters in brackets refer to the supply sources listed at the end of the book.

Findings: Completely achromatic material can appear chromatic; hence, color cannot be a property of this material. The thin layers of cellophane cause refraction processes to develop which are then superimposed in polarized light. The eye is made to produce color sensations. In this case we are talking about interference colors. By rotating the upper polarization filter, the refractions and superimpositions are altered and therefore lead to different color perceptions. Comparable examples: Newton rings or oil slicks on wet streets. Even raindrops that produce a rainbow due to refraction involve achromatic material.

§ 2 Material Color Is Relative

Material does not reveal any fixed, specific color. Its appearance instead is relative. It depends on the existing illumination.

The color appearance of material is called "object color" (or "surface color"). Different materials are distinguished in terms of their chromatic appearance because they absorb different spectral segments from the existing light. Object color, therefore, materializes due to the individual absorption capacity of the particular material.

The information, of course, is transmitted to the observer through the nonabsorbed portion of the light that reaches the eye as a "color stimulus." This nonabsorbed portion is reflected (remitted) in the case of opaque materials and is allowed to pass through (transmitted) in the case of transparent materials. Hence, the hue perceived is the remnant of the light that strikes the eye—in other words, the "residual light."

Depending upon the spectral composition of the light, there is also a change in the spectral composition of the color stimulus that reaches the eye as information. Hence, a certain hue cannot be assigned to a specific material; instead, the specific material can take on the appearance of different hues.

Demonstration:
Illumination box with various types of light
Uniformly colored sheets of paper or cardboard

Mount four fluorescent light tubes in the four compartments of the illumination box (color fig. 2 A-D) so that each illuminates a section of the

same colored cardboard. These tubes, as shown in fig. 1, should be covered on the side facing the viewer. Going from top to bottom, the box should be equipped with the following types of light [B]: cool white deluxe—warm white deluxe—home light deluxe—daylight.

In everyday language, each of these light qualities is referred to as "white." Nevertheless, the colored cardboard pieces look different in each

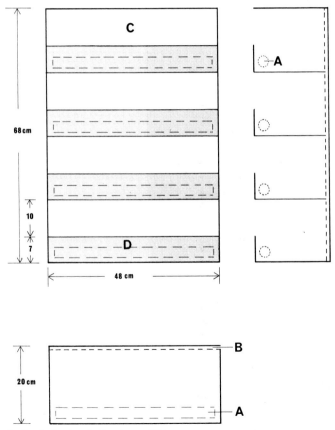

1 Illumination box for four types of light

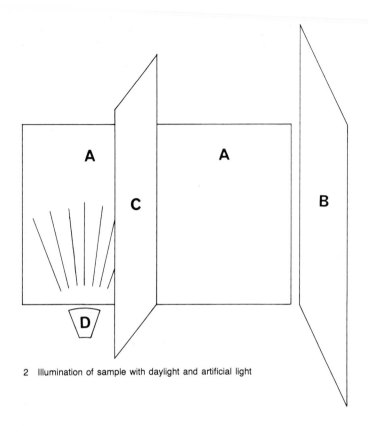

2 Illumination of sample with daylight and artificial light

compartment. We can detect the slightest differences in orange-red and yellow hues because each of the types of light has strong intensities in the corresponding spectral sectors. The differences emerge clearly in the case of the green-colored cardboard pieces. They increase considerably in blue, violet, and magenta hues.

The greatest effect occurs with light blue hues. This is because the appearance now actually "flips over," as we can see in color fig. 2 D. In yellowish light types, we cannot see anything at all of the light blue color; the hue of the cardboard is perceived as a warm gray. (Fig. 2 shows how this experiment can also be performed with the very simplest means. Place colored cardboard A laterally in the daylight coming from window B, and

cover one half with perpendicular board C, or the like. We shine a lightbulb, D, into the shaded portion thus created. The viewer must now position himself in such a manner that he will be able to see both halves simultaneously.)

Findings: The appearance of object color depends on the spectral makeup of the existing light. If the latter changes, there is also a change in the hue perceived. This is because only the radiation intensities that are also present in the available light can be remitted or transmitted as color stimuli. The same material thus shows different hues, depending upon the illumination situation.

§ 3 Achromatic and Chromatic Adaptation
The visual system has the ability to adjust to the particular illumination and to the observation conditions.

It is obviously not the eye's primary purpose to produce esthetic sensations. In the history of man's evolution, its purpose was apparently to provide reliable orientation and thus to make the survival of the human species possible in the first place. The visual system has an adaptation mechanism that continually attempts to adjust to an average perception level. This happens so that optimum discrimination possibilities will be present in every respect.

The visual system can adjust to quantitative and qualitative changes in the conditions of illumination and observation.

Quantitative adjustment is called "achromatic adaptation." The eye adjusts to the intensity of illumination, in a manner similar to a camera. In the case of photography, the quantity of light is varied by the shutter, and in the case of the eye it is varied by the iris. If the shutter adjustment is not sufficient, one can use different film speeds in photography. In the case of the eye, a physiological mechanism goes into action if the margin of the iris is either exceeded or not reached.

The qualitative adjustment of the visual system is called "chromatic adaptation." There are three different types of receptors, called "cones," in the retina, which are sensitive to different spectral sectors. Each receptor type is matched with a particular sensory power. Chromatic adaptation occurs because these three sensory capacities adjust differently, in keeping with the

spectral composition of the light; specifically, each one of them adjusts individually for its spectral sector.

Achromatic adaptation enables the individual to orient himself safely, after a period of adjustment, not only in a dark basement by candlelight but also in the blinding light of the midday sun on a snow field high in the mountains, where the eye's adaptation capacity (according to Siegfried Rösch) is more than 1:1,000,000.

Chromatic adaptation is the reason why we can recognize and distinguish colors relatively well even in the case of major changes in light qualities.

Demonstration:
White letter paper
Papers of clear and vivid colors, about 5 x 5 cm

Place a black dot in the middle of an orange-red or green piece of paper. Now put the colored paper on the sheet of white letter paper, as in fig. 3. Closing your left eye and covering it with one hand, stare at the black dot on the colored paper. Note that the intensity of color perception abates gradually; specifically, in the middle of the color sample faster than along its edge. After one or two minutes, open your left eye and close your right eye. The intensity of perception is now considerably greater on the left than on the right. By alternately opening and closing both eyes, you can clearly compare the two different perceptions.

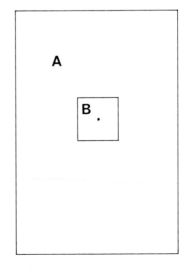

3 Adaptation of the eye

Findings: The visual system has an adaptation mechanism that can adjust to the quantity and quality of illumination. In the case of achromatic and chromatic adaptation, both eyes react independently of each other, however. Even in the case of fixed illumination and observation conditions, the appearance of a color sample changes if one stares at it long enough. Hence, there is no fixed relationship between the color stimulus and color perception.

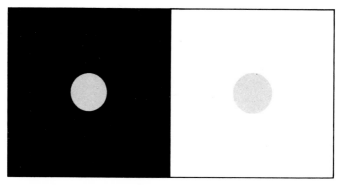

4 Achromatic simultaneous contrast

§ 4 Effect of Surrounding Colors
The appearance of a hue is altered by surrounding colors.

Under fixed illumination and observation conditions, after the eye has adapted, the same color sample can reveal different hues, depending only upon the colors surrounding it. This phenomenon is called "simultaneous contrast." We must distinguish here between "achromatic simultaneous contrast" and "chromatic simultaneous contrast."

We have achromatic simultaneous contrast, for example, when, as in fig. 4, the same light gray looks darker against a white background than against a black one.

We are dealing with chromatic simultaneous contrast when a color sample changes its chromatic appearance due to the influence of surrounding colors.

Demonstration:
Magnetic board or adhesive board [C]
Adhesive colored paper
Good illumination

Using the same light brown colored paper, cut out two banana-shaped pictograms. Glue them on adhesive material, for example, magnetic foils [C], and staple them next to each other on an adhesive board, for example, a magnetic board. Of course, both bananas now reveal the same hue. But this changes when you place a yellow colored paper behind one of them and a dark blue colored paper behind the other. (It suffices here to glue magnetic foils on both of these sheets of paper with a format of about 8 by 12 inches on the upper edge, something which is best done with all purpose glue [K]. Color fig. 3 shows the resultant effect. On the left, the light brown looks darker, dirtier, and more unappetizing against the surrounding yellow field. Against the dark blue, it looks more yellowish, brighter, and cleaner.

Findings: Although objectively identical color stimuli can strike an observer's eye from two color samples, it is possible to perceive two different hues. What we call simultaneous contrast consists of correction processes that the visual system performs according to laws of its own for the purpose of altering color sensations. These shifts are obviously intended to make differences more clearly recognizable.

Hence a definite hue cannot be assigned to a color sample. This is impossible even in the case of standardized illumination and observation conditions, because the appearance of color samples is influenced by surrounding colors. Simultaneous contrast proves that there is no fixed relationship between color stimuli and resultant color sensations.

§ 5 Afterimage Colors

Afterimage colors make it possible to reveal the visual system's adaptation mechanism.

The visual system not only has the ability to convert information reaching it with the color stimulus into corresponding color perception. Instead—as proven by adaptation and simultaneous contrast—there is a correction mechanism that performs adjustment processes according to a law of its own. We can study the

manner of this adjustment in "afterimage colors" (also occasionally called "successive contrast").

Demonstration:
Magnetic board or adhesive board
Adhesive colored paper [D]
Good illumination

Color fig. 4 shows an arrangement of colored papers with which interesting afterimage effects can be demonstrated. It is very effective to work with correspondingly large-format colored papers on a magnetic board which, for example, is illuminated by the light from a projector or an overhead projector. The indication [D] pertains to colored papers where light orange and green are much purer than it was possible to reproduce with the printing colors used in the color figure. (The purer and more luminous the colors are, the better these effects can be rendered visible and the shorter the adaptation time will be.)

This experiment should be conducted in such a manner that the observer stares at the black dot in one of the fields for at least 60 seconds; this means that both eyes should try to "stick to" the dot for this span of time. Try to view the dot ever more sharply and to keep your eyes from shifting away. The darker and the more impure the hue is, the longer it should be viewed. It is a good idea to count very calmly from 21 to 80. If the time is not sufficient to allow the afterimages to materialize clearly, it should be extended. With suitably bright illumination, these afterimage effects can be experienced using color fig. 4.

Start by staring at the black dot in the yellow field. After at least one minute turn your gaze toward the black dot that stands freely on the white surface to the right, next to it. You will now see a violet-blue afterimage. If you go from magenta-red to white, you get a green afterimage; if you go from cyan-blue to white, you get an orange-red afterimage. But if you stare at magenta-red and then shift to the left, to orange, the latter will change into yellow and, in the case of suitably colored papers, will almost no longer be distinguished from the yellow circular surface below. You will see the beginning of the glimmer of a green afterimage color only gradually, with a delay, on the white field surrounding the orange. If you conduct this experiment in the reverse sequence, the square standing on its tip in the magenta-red-colored surface looks as if it had changed toward violet-blue; in everyday language we would call this shade "lilac." Now proceed in a similar manner with the two lower color fields. As we go from green toward cyan-blue, it is changed toward violet-blue. But if we go conversely from cyan-blue toward green, the latter is altered toward yellow. Here again we

see the afterimage color in the white field surrounding the green surface only after some delay.

This experiment should be conducted slowly and deliberately. The black dot on a color surface should be stared at until the intensity of color perception has been heavily reduced due to alteration. These alterations can be recognized in the unavoidable minor eye fluctuations by virtue of the fact that dark edges materialize along the rims, which, however, naturally disappear again when the eyes move in the opposite direction.

Findings: Staring at a hue leads to an adaptation of the visual system; the intensity of color perception is progressively reduced. We observe how the physically identical color stimulus produces continually changing color sensations. If, after a sufficient interval of time, we switch the eye from a colored surface to white, we get an afterimage color. But if we turn it away from the colored surface toward another colored surface, the resultant afterimage color will be mixed with the sensation that is produced by the existing color stimulus.

The color stimulus causes the visual system to act: it produces a certain color sensation. The afterimage color, on the other hand, is a reaction by the visual system, which comes about when white light strikes the same point in the retina in place of a long-lasting "chromatic" color stimulus. (We will understand this clearly subsequently when we have obtained an accurate knowledge of how the visual system works.)

§ 6 Color Is Only Sensory Perception

The outside world is colorless. It consists of colorless matter and colorless energy. Color exists only as an observer's sensory perception.

From sections 1-5 we can deduce that color is not where we see it. Green is not in the lettuce leaf. Red is not a property of the fabric of a dress. The lettuce leaf and the dress fabric merely have an individual absorption capacity that enables them to absorb certain spectral elements from the general illumination. The portion that is not absorbed is then remitted as residual light. The light rays from this remission are not a color themselves. They are merely

transmitters of information. They tell us how this color stimulus differs from the spectral makeup of the general illumination. Color materializes only if this color stimulus causes the intact visual system of an observer to produce a color sensation. If there is no such observer, then this color cannot materialize. If the same color stimulus strikes the eyes of a person with defective color vision, a different color sensation will result.

Demonstration:
Darkened room
Colorful objects or baskets containing fruit and vegetables
Projector with color filters: interference filter [E]

Place a basket with ripe tomatoes, cucumbers, yellow apples, radishes, oranges, etc., on the table. Black out the windows. The color of the fruits can be perceived at normal room light. Now turn off the light in the room. Naturally, everything is dark; the colors will disappear. Then illuminate the fruits, for example, with an orange-red light generated by a narrow-band interference filter in front of a projector. The fruits can be seen again, but the appearance of their color has changed. While we believe we can perceive the inherent color of the orange, the green cucumber will look black and the yellow apple will appear orange-red.

Other filters [E] should also be used for this experiment and the deviating color changes should be observed. It is also interesting to illuminate a systematic assembly of colored papers with changing light colors and to study the shifts in color sensations.

Findings: To be sure, we normally consider the absorption capacity of material to be its object color and we consider the spectral composition of a radiation to be its light color. In reality, however, absorption capacity is only a latent ability and light rays are only information messengers that provide information, the way the postman delivers a letter. Color is only the product of the visual process, that is to say, color sensation.

It is therefore impossible to try to discover the interrelationships between color origin and color mixing laws through the study of the color stimulus, i.e., the visible electromagnetic radiation that strikes the eye. This is because the higher law of color theory is nothing—and cannot be anything—but the principle according to which the visual system functions. The law of vision is the basic law of color theory.

How the Human Visual System Works

§ 7 The Visual System as a "Computer System"

The visual system works like a computer system in which the eye is the input unit and the brain is the arithmetic unit. Color sensation is the output product.

The arithmetic unit in a computer system is limited in terms of its operating possibilities by the number of storage locations and by the existing programs. The output units likewise have only limited operational possibilities. Regardless of whether we are dealing with a high-speed recorder or a video display unit, the number of lines and the number of letters in every line are strictly fixed. Not one line more than has been provided for one page can be written. Not one letter more than provided for will fit into one line.

The input unit has the purpose of translating the incoming information into "computer language." The information is edited so that it can be processed by the system. The type of information carrier basically plays no role here. But it is always important to adjust the input unit to the information carrier so that the information can be received in a practical manner.

Demonstration:
Magnetic board or adhesive board
Prepared adhesive symbols (color fig. 5)

The individual symbols should be explained as they are placed on the adhesive board.

In the upper portion of color fig. 5, we see the essential components of a computer system. There are fixed correlations between the arithmetic unit (R) and the output unit (A). They are determined by the number of storage locations, the existing programs, and the output unit's capacity. The input

unit (E) edits the incoming material to adjust its content to the existing prerequisites in terms of the equipment and the program.

We must visualize the way the visual system works through a comparable process. This is made clear through the comparison with the symbols in the lower part of color fig. 5.

The task that the arithmetic unit has in the computer system is performed by the brain. The generation of color sensation corresponds to the activity of the output unit. The eye is the input unit of the visual system. It has the task of "querying" the information carriers (that is, the energy rays that we call light rays). It translates the communications into the system's language. To fully exhaust the processing capacities of the brain and the potential of perception output, it performs correction and adjustment processes, which we know by the names of adaptation and simultaneous contrast. This adjustment is determined by the existing illumination and the observation conditions.

We must distinguish here between quantitative and qualitative adjustment processes.

The iris of the eye works like the shutter of a camera: the incident light quantity is controlled by the size of the opening. When the smallest or the largest opening possibility has been reached, this mechanical quantitative control is followed by a physiological adjustment mechanism (adaptation).

But the visual system also possesses the admirable ability to adjust to the quality of the existing illumination. This is done as part of an effort to make color differences appear as clearly as possible in spite of the altered spectral composition of the light.

Findings: The energy rays of the light stimulus are not colors, but rather information transmitters that can be compared to a punched or magnetic tape. Hence the color stimulus is not the information, but rather its carrier.

Only after the input unit represented by the eye has taken care of the conversion and preprogrammed it can there be real information—that is, color sensation. The correction processes are oriented in terms of the intensity and composition of the existing light, on the one hand, and by the individual viewing conditions, on the other.

In other words, there are no fixed correlations between color stimuli and color perception. This is why it is impossible to derive the interrelationships of color theory from an analysis of color stimuli.

§ 8　The Three Primary Colors

There are three cell types in the eye, which are linked to three perception capabilities. These perception powers represent the primary colors violet-blue, green, and orange-red.

The retina of the normal human eye contains three types of cells which are sensitive to radiations of various wavelength sectors; they are called "cones." In addition there are the "rods," cells that apparently can perceive only differences in brightness. These cells are tiny antennas, of which there are about 15,000 on one square millimeter of retina.

They work in a manner similar, for example, to the aerials of transistor radios, which intercept electromagnetic radiation. Vision cells also intercept electromagnetic radiations, that is to say, light rays. While the transistor radio converts imperceptible radiations into acoustic signals that lead to corresponding acoustic sensory impressions, the visual system allows optical impressions to arise.

Hence the cones do not *see* color. Instead, their job is to intercept and catch light quanta. The cones are quanta collectors that convert the external electromagnetic radiation energy, which transmits the information, into the electrical impulses of the visual system. These impulses are carried by the nerves to the brain, where a corresponding sensory perception is brought about.

Demonstration:
Magnetic or adhesive board
Adhesive picture elements (color fig. 6)

First attach a strip to the upper portion of the magnetic board that schematically shows the "colors" of the spectrum. (The spectrum will be explained in detail later.)

Now add three curves in the middle. Each curve (likewise schematically) shows the sensitivity range of a cone type. We can see how the three sensitivity ranges overlap each other. By comparing the particular curve with the spectrum above it, we can identify which radiation sectors were recorded by which cone types.

The curves, however, also show how the radiations in the particular cone lead to reactions of differing strength. There is a maximum sensitivity in each reception sector. This sensitivity diminishes, according to the curve, toward both sides. There are certain radiations in the spectrum that do not affect certain cone types at all.

Now place the color strips in color fig. 6 on the lower portion of the magnetic board. These strips are (again schematically) intended to show how a sensation capacity in the visual system is matched up with each reception sector. Each cone type has its own perception power, which can be referred to as a "component."

These three sensory powers are the three "primary colors" that we call violet-blue, green, and orange-red. (These names should absolutely be put to general use to eliminate confusion. They should not be called "blue," "green," and "red," as unfortunately is still often the case and is one of the reasons for misunderstanding in color theory.)

Another misunderstanding should be carefully avoided here: the reception sectors of the cone types must under no circumstances be confused with the sensation powers themselves, in other words, with the primary colors! This is because each cone type collects its own quanta, in partially overlapping spectral sectors. This means that the same spectral sector of a color stimulus can simultaneously affect two different cone types. But the three perception powers, the three primary colors, are magnitudes that are independent of and separated from one another.

Each primary color has a certain potential. The maximum value is given when the total existing potential has been exhausted. This is the case when an increase in the specific radiation intensity no longer leads to an increase in the resultant color sensation.

Thus it happens that the visual system is caused to form three-part codes for the information transmission of the color stimulus. Each possible color perception is represented accordingly by such a code. The code reaches the brain as a three-part electrical impulse via the nerve paths and causes the brain to produce a corresponding color sensation. We must assume that there are fixed correlations between the codes and the color sensations. This is because the adjustment processes that we have previously discussed have already taken place prior to the formation of the code.

Findings: The cones in the retina of the eye do not see colors. They are collectors of quanta. The three components of the visual system are the three primary colors. A three-part code is formed from them for each color sensation. The primary colors are violet-blue, green, and orange-red.

§ 9 Vision Defects

Defects of the visual system are defective color vision, color blindness, and blindness.

People who have a normally functioning visual system are referred to as color-efficient.

Disorders of the visual system can be inherited or acquired. Inherited disorders are extraordinarily frequent; they can be found in about 8% of all males but only in about 0.4% of all females. This is due to the fact that this hereditary predisposition is passed on recessively by the pertinent chromosomes. The type and extent of visual disorders can be determined roughly by so-called pseudo-isochromatic color plates.

There are people who are only able to perceive differences in brightness. These individuals could be called "black-and-white viewers." The technical term for this disorder is "monochromasy."

Others can distinguish certain brown-yellow hues from certain blue ones, in addition to brightness. Others can see, in addition to brightness gradations, differences between certain red and green hues. This disorder is called "dichromasy."

We speak of color blindness when the corresponding cone types do not function at all. But if their activity is only reduced, we are dealing with "color vision weakness" or "defective color vision."

People are blind when no vision cells react.

The term "night-blind" (nyctalopia) is applied to those individuals whose rods do not function. These people are no longer in a position to orient themselves when the illumination level drops below a certain point. Here it is obviously the rods which still permit vision in case of a minimum level of illumination.

Demonstration:
Color-Matching Aptitude Test (see Bibliography:
Inter-Society Color Council)
Good illumination

In this test the sensory color perception of a person is examined. There are about 50 hues arranged in 4 rows in the color ranges blue, green, red, and yellow. There are only small differences in color appearance between the hues. The person being tested gets a chip for each hue one after the other. He has to decide where he finds equal color appearances. The number of the individual chip is written down in the attached field. The result of this test

yields exact information about the visual capability of the person being tested. Not only will kinds of defects be clear, but also degrees of weakness.

If uncertainties or defects in color vision are established during such an examination, the test subject should be sent to an eye doctor. The type and extent of visual disorders can be established in a careful examination, using special instruments.

A conscientious examination of color vision is urgently recommended to every young person if he or she intends to choose a career in which color efficiency is an imperative requirement. There are many more occupations where this is the case than one might initially assume; color efficiency is important not only for artistic work with color, but also in the many areas of industrial color application: for example, in the textile industry, in the printing industry, in the entire television industry, in the painting trades, etc. Even a medical-technical assistant who is color blind cannot successfully perform certain microscopic examinations of stained samples or specimens; and even a good dentist must be color-efficient if he does not want to make mistakes in the selection of tooth substitutes.

Findings: We are dealing with color blindness when certain cone types do not work. Defective color vision comes about due to reduced capacity on the part of the cone types concerned.

§ 10 Adjustment Processes Optimize Recognition
The visual system always attempts to adjust to an average perception level.

In the case of adjustment to the intensity of general illumination (achromatic adaptation), the perception level of all three components (primary colors) is raised or lowered uniformly and identically.

In the case of adjustment to altered light qualities (chromatic adaptation), the components are adjusted in various ways. In keeping with the particular spectral makeup of the light, there is a different level for each component. The differing radiation intensities for the three reception sectors are in this manner compensated for as much as possible by a physiological process that runs in the opposite direction.

Light from a light bulb, for example, has only low radiation intensity in the shortwave range. (A precise explanation of the physical facts involved here will follow later.) This is why the

corresponding sensation power, that is, the primary color violet-blue, is increased and strengthened; it is additionally sensitized. At the same time, the perception capacities for medium-wave and long-wave radiation, that is, the primary colors green and orange-red, are reduced and weakened in terms of perception level.

By means of this adjustment to average sensation levels, individually for each component, the visual system manages in each case to create the best possible orientation and perception. From this average level, differences can always be best perceived both in the direction toward brighter and in the direction toward darker. Simultaneously, however, we also have the best prerequisites here for the perception of color differences.

This adjustment mechanism is obviously constructed so that it can become effective in segments of the retina as well. This is how we can explain the effects of afterimage colors and of simultaneous contrast (change in the appearance of a hue due to surrounding colors). A kind of chromatic adaptation takes place as we stare at, for example, a yellow color surface. The visual system adjusts itself for this retina sector to the spectral composition of the reflection of this yellow surface. Because the color perception "yellow" is brought about by the components "green" and "orange-red," these two primary colors are gradually reduced in terms of perception intensity. The perception level for the primary color violet-blue, which is not affected, is simultaneously strengthened.

If we turn our gaze from a yellow surface at which we have been staring toward a white paper, we detect a violet-blue afterimage color. This demonstrates the adaptation condition of the visual system to the radiation reflected by the yellow surface. We can see these afterimage colors only because all adjustment processes of the visual system take place relatively slowly. This is why we can also accurately observe the duration of the particular adjustment time, which lasts exactly as long as it takes the afterimage color to disappear again.

These adaptation processes obviously relate only to larger retina sectors, because this is the only way we can explain the phenomenon of simultaneous contrast.

Demonstration:
Yellow, green, and magenta-red colored paper [F]
Bright, white light

Cut 10 x 10 cm and 3 x 3 cm pieces out of each of the three colors of paper. In accordance with fig. 5, place identical small green segments on the larger yellow and magenta-red ones. The green in the surrounding magenta-red field looks purer, shinier, and brighter to us than the one in the yellow field.

As we shall learn later on, the yellow color perception comes about due to the cooperation of the primary colors green and orange-red, while magenta-red results from the collaboration of the primary colors violet-blue and orange-red.

The "contrast increase" in simultaneous contrast can be explained in the following manner: on the right side of fig. 5, the green component is strengthened because it is underrepresented compared to the total retina sector affected. On the left side, the primary color green is not boosted, because it is represented both in the yellow and in the green color. This explanation clarifies why green always looks purer and brighter to us in a surrounding magenta field.

In the case of simultaneous contrast, we are dealing with adaptation processes of the visual system related to certain portions of the field of vision.

Hint: One ought to study the other possible combinations of the colored papers. For example, magenta-red in a surrounding green field will look brighter than in the yellow one, etc.

Findings: The visual system performs adjustment processes in certain sectors of the retina. Achromatic and chromatic adaptation, afterimage colors, and simultaneous contrast can be explained by the same adjustment mechanism.

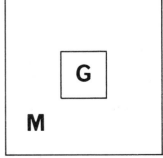

5 Simultaneous contrast of chromatic colors

§ 11 The Eight Basic Colors

The eight extreme sensory positions of the visual system are referred to as "basic colors."

There are eight basic colors that correspond to the three components of the visual system (primary colors). These basic colors are the extreme positions, the extreme possibilities of color sensation that the visual system can produce. They result, purely mathematically, from compelling logic. This is because these three factors have the eight following variation possibilities (see the chart in fig. 6): two achromatic and six chromatic basic colors. The achromatic basic colors are white (W) and black (B). We call the chromatic basic colors yellow (Y), magenta-red (M), cyan-blue (C), violet-blue (V), green (G), and orange-red (O). (*Note:* These unequivocal names for the eight basic colors were already proposed by Louis Cheskin, director of the Color Research Institute of America. [*Cheskin Color Chart.* New York: The Macmillan Company, 1954.] The only difference is that Cheskin used the term "green-blue" for the basic color that we call "cyan-blue.")

Demonstration:
Magnetic board
Eight rectangles as adhesive pictures in each of the colors V, G, and O
One color field, each, for Y, M, C, and W [G]

Arrange the total of 24 rectangles (eight for each of the basic colors V, G, and O) on the magnetic board as shown in fig. 7. This creates the initial position for the explanation of how the eight basic colors originate from the three primary colors.

The further development will emerge clearly from color fig. 7. All three primary colors remain in the uppermost position (left side). This is paralleled (on the right side) by the perception of the achromatic basic color white.

Two primary colors each remain on the left side in the horizontal row underneath. This is paralleled on the right by the perceptions of the chromatic basic colors yellow, magenta-red, and cyan-blue. (Remove the unnecessary magnetic images and push the remaining ones correspondingly closer together.)

Now go down to the next row. Where (in fig. 7) there had been three primary colors in each place, we are left with only one each now. Move this one as shown in color fig. 7. The primary colors orange-red, green, and violet-blue are paralleled by the perceptions of the basic colors orange-red,

Primary Colors	Basic Colors
V + G + O	W
G + O	Y
V + O	M
V + G	C
V	V
G	G
O	O
No Value	B

6 Connection between primary colors and basic colors

green, and violet-blue. This is because the individual primary color, naturally, is also an extreme color sensation.

Finally, remove the three lowest rectangles (fig. 7) entirely. From color fig. 7 we can read that, where no primary is in effect, the color perception black will materialize (B).

Naturally, it is very helpful to conduct this experiment with two magnetic boards next to each other in order to get the arrangement in color fig. 7. Where this is not possible, it is recommended, for Y, M, C, and W, to make the color fields as adhesive images, as we see in the color figure (right side). By explaining the matchup of perceptions for the combinations, one can "pick up and take along" the larger color surfaces above the primary color fields below. In this way, the interrelationships here can be clearly presented to students.

Because, in this system, black cannot be illustrated by means of a surface, it would be a good idea to make a black B as an adhesive letter.

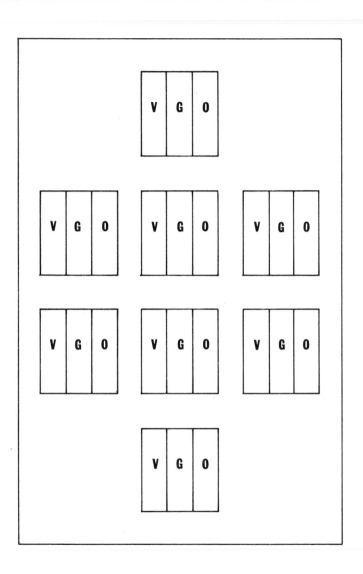

7 Demonstration of the eight extreme sensation possibilities

On the other color fields in color fig. 7, letters naturally are necessary and meaningful only if you want to make sure that color-blind individuals will also be able to understand these principles.

At this point we might already note that one needs all of these eight basic colors together if, for example, one works with opaque artist's oil paints. We cannot do without any one of them. We will come back to this later when we look at the laws of color mixing.

Findings: The eight basic colors are the eight undivided variation possibilities resulting from the three primary colors. They represent the extreme color sensations that the visual system can produce.

Important Hint: There is no chromatic material capable of causing the visual system to produce the extreme chromatic color sensations, i.e., the primary or basic colors; at best, these might be approximations. The colored papers used therefore cannot be identical to the ideal positions meant here. Instead, they are merely symbols of the primary and basic colors.

Systems and Models for Illustrating the Law of Vision

§ 12 The Primary Color Code Number System

The primary color code number system designates one million hues.

An individual hue is not represented by a material sample (color sample) or a color stimulus, but rather by a color sensation. There are as many color sensations as there are quantitative variation possibilities for the primary colors. That would be, theoretically, an infinite number.

In practical terms, however, it would make no sense to work with a visualization of an infinite number of hues; we must select a limited number from among this infinite variety. It is completely unnecessary here to select the steps between the individual hues smaller than the color-efficient color expert or the most sensitive color artist would be able to discriminate.

This is why we proceed in the following manner: we shall consider the maximum sensation potential of a primary color (component) to be 100%. We will take the one-hundreth part of the maximum sensation, in other words, 1%, as the calculation unit. This is a portion (quantity component) which we can call a "sensation quantum."

In order to designate the perception volume of each of the three primary colors in a code, we will give the number of sensation quanta. This is done in the sequence V, G, O.

So that we can designate the volume of each individual primary color with only two digits, we equate 100 with 99. Hence 99 signifies the maximum sensation. This gives us an error of 1% at the maximum perception level, which is totally insignificant. When

accurate calculating is important, one might even agree that the individual value given is the abbreviation for a number in which, after a decimal point, the same figures that appear before the decimal point are repeated. In that case, 23 becomes 23.23 and 99 becomes 99.99, etc. By means of this simple primary color code number system, we are able to precisely designate a million codes and thus a million hues (color sensations).

By thus giving the number of sensation quanta for each primary color (Pri), we get a "telephone number" for each code consisting of three groups of two digits each. From the first group of numbers we read off the quantitative value for the primary color violet-blue, from the second one we read off the value for the primary color green, and from the third one, the value for the primary color orange-red. We refer to this "telephone number" as the "primary color code number" (PriN). For example, a PriN can look like this: 32 09 87. This means that Pri V participates in the materialization of the pertinent color sensation with 32 quanta (32%), Pri G with 9 quanta (9%), and Pri O with 87 quanta (87%).

V	G	O	H
99	99	99	W
00	99	99	Y
99	00	99	M
99	99	00	C
99	00	00	V
00	99	00	G
00	00	99	O
00	00	00	B

8 Mathematical relationship between primary and basic colors

Demonstration:
Blackboard
Colored chalk in the eight basic colors

Using white chalk, draw the box shown in the chart in fig. 8 on the blackboard. It has three columns on the left, next to the double perpendicular line, and one column on the right. On top of the columns write, in capital letters, in a sequence from left to right, V, G, O, and H. This means that, on the left, we have one column for each primary color. The H on top of the right-hand column means "color sensation" or "hue."

Now enter the primary code numbers for the eight basic colors (BC) in the little box thus prepared. Follow the sequence shown, starting with W, in order to arrive via Y, M, C, V, G, and O at B. In doing so, write the abbreviation for the basic colors with the corresponding colored chalk. In the case of B, improvise by drawing a double outline.

With the primary color code number system, we can illustrate how the visual system works in a purely mathematical manner. The eight primary color code numbers in the little box in fig. 8 refer to the eight possible extreme combinations and thus to the eight basic colors. All possible variations lie between these extreme numbers. In this way the entire variety of colors that the visual system is capable of producing can be recorded numerically and therefore mathematically.

By means of the arrangement in the chart, we can memorize which digit group was matched up with which primary color. Now erase the chart and write only the primary color code numbers on the blackboard. Do this in such a manner that the first group of digits on the blackboard is with violet-blue, the second one with green and the third one with orange-red chalk. First use only the code numbers for the eight basic colors; then try to find out the pertinent perception.

For example, if the question is: what basic color is designated by the primary color code number 00 99 99?—the answer must be: yellow.

In the next step, you can omit the colored chalk and use only white chalk. Then you can switch to writing any desired primary color code numbers on the blackboard and explaining which primary colors are involved with which volume and the color perceptions that will result.

Findings: A primary color code number is similar to a telephone number; it designates a certain color sensation. The first group of digits gives us the value for the primary color V, the second for the primary color G, and the third one for the primary color O.

§ 13 The Four Basic Color Components of a Hue (The Component Diagram)

A maximum of four basic color components can be derived from the three-part code of the primary color code number.

From the purely numerical (mathematical) description of the situation we now switch to a surface-related (graphic) one.

But we must first clarify a linguistic difficulty in order to eliminate any confusion. We must distinguish clearly between the perception powers of the visual system, which we also refer to as components or primary colors, on the one hand, and the resultant color sensation, on the other hand. While the components describe the forces existing in the working mechanism of the visual system, in the case of color sensation we are dealing with the product of its "output unit."

The linguistic difficulty consists in the fact that the meaning of the difference between the concepts "perception power" (in other words, component) and "color sensation" (in other words, output) is not sufficiently clear, and hence confusion can easily arise. This is why we will use the concept "primary color" (Pri) exclusively for the three perception powers and the concept "basic color" (BC) exclusively for the sensation output. In the following demonstration we will see how each color sensation can be described by the basic color components.

The law according to which a maximum of four basic color components can arise from three primary color volumes can most easily be explained by a graphic illustration.

Demonstration:
Blackboard
White chalk

Using chalk, draw the basic diagram in fig. 9 on the blackboard. In the left-hand square there are three vertical columns representing the three primary colors. The total content of the square, marked by the heavy black line, thus illustrates the total sensation potential of the visual system. The arrow points to the rectangle H, which represents the resultant color perception, that is, the hue.

You can also present the rectangular vertical columns V, G, and O as tubes fiiled with liquid. Thus any desired level is possible in each of the three tubes. But none of them can be "emptier than empty" or "fuller than full."

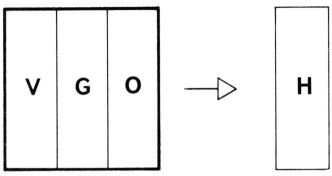

9 The sensation H resulting from three quantity components

In the individual tubes, the space that is not "occupied" by liquid is filled with air, so that there will always be two quantitative portions in each individual tube, whereby each of the portions naturally can also have the values 00 or 99. If we have three "tubes," we can have a maximum of four portions, that is:

1. The same quantity in all three tubes
2. The same quantity in only two tubes
3. A larger quantity in one tube
4. Volume not filled up by any of the three tubes.

With the help of the diagram in fig. 9 you can graphically illustrate the mathematical interrelationships of the primary color code number system in a clear visual fashion. By shading the columns or by coloring them in, you can once again explain the situation in the chart in fig. 8. Enter the portions of certain primary color code numbers in the columns. Fig. 10 shows how this would look for the primary color code number 91 13 36. The arrow tells us that any arbitrary code adjustment in the visual system's operating mechanism leads to a corresponding color sensation H, in other words, to the pertinent hue.

But now we come to the interesting consequence that is shown schematically in fig. 11. The broken horizontal lines indicate the formation of portions on the sensation side. While on the left we are always dealing exclusively with three primary color quantities, we get a maximum of four basic color components on the right.

The highest common level in all three primary colors brings us to a portion of the achromatic basic color white (W).

Depending upon the arrangement, we get a portion of yellow or magenta-red or cyan-blue when volumes are present in only two primary colors. In our example, we are dealing with one portion of M.

The larger value of only one primary color allows portions of the chromatic basic colors violet-blue or green or orange-red to result; in this case we are dealing with a portion of V.

The potential that is not exhausted between the primary color with the highest level and the maximum sensation possibility gives us a portion of the achromatic basic color black (B).

The same situation can also be illustrated numerically; it is best to start with the lowest line in writing this down:

$$
\begin{array}{rcl}
00\ 00\ 00 & = & B_{08} \\
55\ 00\ 00 & = & V_{55} \\
23\ 00\ 23 & = & M_{23} \\
\underline{13\ 13\ 13} & = & \underline{W_{13}} \\
91\ 13\ 36 & = & 99
\end{array}
$$

The portion of the achromatic basic color B is equal to the difference between the sum of the other basic color portions and 99.

Findings: The primary color code number designates the quantitative values of the three primary colors, which stand vertically next to each other. Horizontally, we can derive a maximum of four basic color components.

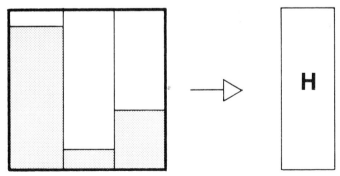

10 An arbitrary arrangement of components

§ 14 The Six Groups of Basic Color Quantity Components (Mechanical Model for the Explanation of Color Sensation Origin)

In the origin of sensation, the basic colors form six groups of possible portion combinations.

The logical consequence of fig. 11 is the fact that the basic colors, in connection with perception output, can appear only in six different groups. This is an extraordinarily interesting and important finding in view of the total of eight basic colors.

11 Origin of four portions

Fig. 11 clearly shows that portions of the achromatic basic color W result whenever the third primary color is added. On the other hand, portions of the achromatic basic color B result where the available sensation potential is not taken up by at least one primary color. This is why only the following groups are possible:

WYGB
WYOB
WMOB
WMVB
WCVB
WCGB

In looking at these possible combinations, we are struck by the fact that the two achromatic basic colors W and B are present in

each group. In addition, we have two chromatic basic colors in each case, specifically, those that are next to each other (on the color hexagon with which we will become familiar later). For the sake of order, it must be pointed out again here that the value for each one of the four portions of these basic colors that constitute one such group can also be either 00 or 99. We always get 99 as the sum of the basic color quanta of all four portions in one group. This is because, on the side of the sensation output, we are always dealing with a single hue that can only be made up of 99 basic color quanta (100 percent = 99 mathematical units).

From the basic color combinations in the group it follows that, for example, the basic color magenta-red can never occur together with yellow or cyan-blue. Magenta-red can only appear together with the chromatic basic colors orange-red or violet-blue. These interrelationships correspond exactly to what we will later become familiar with as the "law of integrated color mixing," in other words, the law that relates to the mixing of coordinated opaque color media (for example, oil paints on the artist's palette) which must be mixed first and then applied in a single opaque coat. If, in such a system, magenta-red were to be mixed with yellow, we would obtain achromatic values. In that case, we would be dealing with portions of the achromatic basic color W. In the case of integrated mixing, however, the achromatic values of the hues are always directly formed by portions of the achromatic basic colors W and B.

Demonstration:
Various sizes of stiff cardboard
Colored paper in the eight basic colors, glue
Silver paper or silver paint

Make a mechanical model whose purpose is to graphically demonstrate all the possible variations in the primary colors. In this way it illustrates all imaginable code adjustments. This corresponds to the total sensation potential of the visual system.

The model will demonstrate for all hues what was shown in fig. 11 for one hue (fig. 12). The square with the heavy black line around it in the upper left corner, again represents the entire sensation potential, in the same manner as in figs. 9-11.

This square, however, is now a window cut out of a large sheet of stiff cardboard. The rectangle on the right side, likewise marked by a black line,

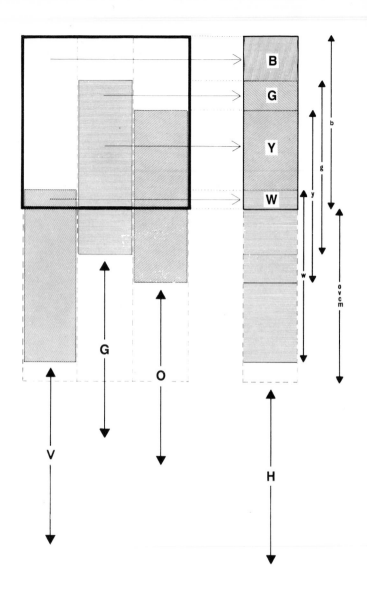

12 Mechanical model explaining color perception

is also cut out to form a window. This window has the same function as the rectangles in figs. 9-11 because it again represents the sensation output or the hue.

From the viewing side, the sheet of cardboard should be covered with glued-on silver paper or be painted with silver paint, to avoid "competition" with the colors that will appear in the windows. (If silver is not available, a medium gray can be used.)

On the reverse side of the cardboard, under the square window on the left, arrange a slide for each primary color in such a manner that it can fill out one third of the window surface. Looking at it from the front, the slides are placed next to each other in the sequence V, G, and O, as shown in fig. 12. The heavy black arrows indicate the direction of movement of the slides. Of course it is advisable to make the slides longer toward the bottom than shown in the diagram, so that they can move in a guide device or simply be attached with adhesive tape.

Behind the narrow window on the right, arrange eight slides, one for each basic color. It is advantageous here (going from the front to the rear) to follow the sequence: W, Y, M, C, V, G, O, B. The black arrows on the right next to the slides indicate the directions of movement. In this particular code configuration, we moved only the slides for W, Y, G, and B. Those for O, V, C, and M, on the other hand, are in the "resting position," because they cannot be involved in this group of basic colors.

This model can be made even more illustrative by attaching vertical measurement subdivisions measuring from zero (bottom) to 99 (top) on the viewing side between the windows. As in the case of a slide rule, one can also allow a flap with a horizontal stripe to run vertically over the model in order to separate the basic color portions on the right from the primary color volumes on the left.

It would take us too far afield here to describe all of the helpful design details that can be used to make this type of model as perfect as possible; nor do we wish to anticipate the reader's ingenuity and imagination.

Color fig. 9 shows a carefully constructed model, made of light metal in this case. All slides can be moved up from a box at the bottom. The primary color slides are operated from the rear and the basic color slides are operated from the right side. Each individual slide has a handle that can be fixed in position and that protrudes out of the box.

With such a model, it is easy to demonstrate not only how the visual system works, but also to explain the interrelationships connected with the laws of color mixing. In this way what is explained in many steps in figs. 6-12 can be clearly illustrated.

Color fig. 9 shows six different code adjustments: positions A and B illustrate how the basic color Y can come together only with basic color G or basic color O.

Positions C to F show the most complicated possibilities. There are four portions in each case. This is normal for the sensation output of the visual system, because colors without achromatic parts (in other words, without portions of the achromatic basic colors W and B) probably do not occur in nature at all as material colors. They obviously can be produced only spectrally.

Findings: The laws of vision can be demonstrated very clearly with the aid of a mechanical model.

§ 15 Formation of Groups of Primary Color Quanta (The Statistical Quanta Diagram)

Just as atoms combine into molecules, so are primary color quanta combined with each other to form groups.

In our primary color code number system, we calculate 99 quanta (mathematical units) for each of the three primary colors. This means that a maximum of 297 primary color quanta, on the whole, can come together for one hue. Of course this happens only in the case of one hue, that is to say, the one with primary color code number 99 99 99, which represents the ideal white.

In the primary color region of the visual system (calculator), a hue can be composed of any number of quanta between 0 and 297. If we add the number of quanta in the individual groups of digits, we get a "quanta sum" which we can also call the "sum of digits" or simply "sum."

On the output side of the visual system, i.e. in the area where sensation originates, this is fundamentally different. According to our mathematical method, any hue is made up of 99 quantitative units, which we call basic color quanta. We recall that in each case only the quanta of four different basic colors can be involved in the materialization of a hue, even though we have a total of eight basic colors.

Let us take a few extreme examples to show how we always have 99 basic color quanta. The hue 00 00 00 consists of 99 quanta of the achromatic basic color black. The hue 00 99 00 has 99 quanta of the chromatic basic color green. The hue 99 00 99 has 99 quanta of the chromatic basic color magenta-red and, finally, the hue 99 99 99 has 99 quanta of the achromatic basic color white.

We can explain the origin of the basic color quanta in a manner similar to the origin of molecules from atoms. Atoms of the same kind can combine into completely different molecules or forms of matter in a stable fashion, due to correspondingly different combinations. The atoms are the building blocks of which the molecules are made up. In a very similar manner we must now visualize the relationships between the primary color quanta and the basic color quanta. The primary color quanta are the building blocks of which the quantitative units of the basic colors, which we call basic color quanta, are made up.

Obviously, the primary color quanta are under a compulsion to get together, wherever possible, with alien primary color quanta. They seek out "partners" in order to combine, to unite with them into a group.

Molecules are more than just the sum of the participating atoms. Something qualitatively new has come about. Thus the groups that are formed by the primary color quanta are also qualitatively completely different from the sum of the participating primary color quanta.

First of all, in looking at any code, the important thing is to form the largest possible number of groups of three. A quantum of the primary color V in each case combines with a quantum of the primary color G and one of the primary color O. We now obtain something qualitatively completely different, that is to say, a quantum of basic color W. If all of the possibilities for the formation of groups of three have been exhausted, the drive to get together is continued by the formation of groups of two. Now any two remaining primary color quanta try to get together, although this again is possible only among alien quanta. For example, if a quantum of the primary color G finds a quantum of the primary color O, we get a quantum of the basic color Y, in other words, again something qualitatively different. If a quantum of primary color V combines with a quantum of primary color O, we get a quantum of basic color M; if a quantum of primary color V merges with a quantum of primary color G, we get a quantum of basic color C.

Quanta left over after the formation of groups of two logically can no longer find any alien partners; they remain, so to speak, "bachelors." Every leftover quantum forms its own "group" and thus becomes a basic color quantum. If we want to remain with this somewhat human comparison, then, looking at it statistically, we

are dealing on the primary color side with human beings who can live together as families with children or as married couples, or remain alone as single people. On the basic color side, on the other hand, we are dealing with "apartments." A couple with or without children or a single person can live in an apartment. But an apartment can also be empty.

In our approach, the sensation potentials that are not used constitute such empty apartments. In our statistics, they are decisive for the number of quanta of the achromatic basic color B.

We have compared the primary color quanta to individual human beings. Hence the corresponding statistics can be compared to a "population census." We also compared the basic color quanta to apartments. Hence in the corresponding statistics these are recorded like "housing units." Perhaps this example might help to clarify the fundamental difference between primary colors and basic colors.

Demonstration:
Blackboard
White and colored chalk or magnetic board
Prepared diagram (fig. 13)
Adhesive circular surfaces in the colors V, G and O [G]

The "statistical quanta diagram" in fig. 13 is very helpful for clarifying the situation described above and in illustrating the principle of group formation. Each circle represents a place (apartment) which may or may not be occupied by primary color quanta.

The diagram is greatly simplified here to make it clearer and thus more readily understandable. Only nine places are available for each primary color. This means that a place is always taken when it is occupied by 11 primary color quanta (9 x 11 = 99). From the one million hues of the primary color code number system, we selected 1,000 to illustrate in this fashion. These 1,000 hues are entirely sufficient to explain the principle of group formation. Naturally, this involves the explanation of the same situation that was illustrated in the preceding chapter by means of the mechanical model. The method described here requires considerably less in terms of expenditure and effort because it can, in the simplest case, be presented by using chalk and a blackboard.

After drawing the basic diagram in fig. 13 on the blackboard, you can cross off the particular occupied places. You can also draw this diagram on thin paper attached to a magnetic board. The particular places can then be covered with magnetically adhesive circles in the colors V, G, and O.

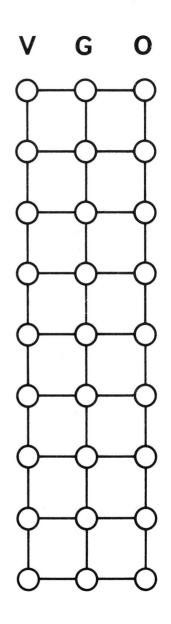

13 The "statistical quanta diagram"

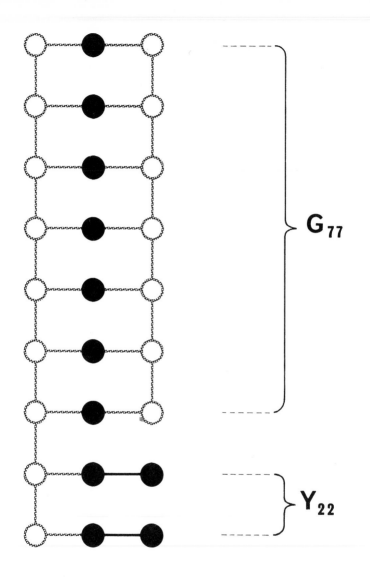

14 Quantity components of chromatic basic colors developing from group formation

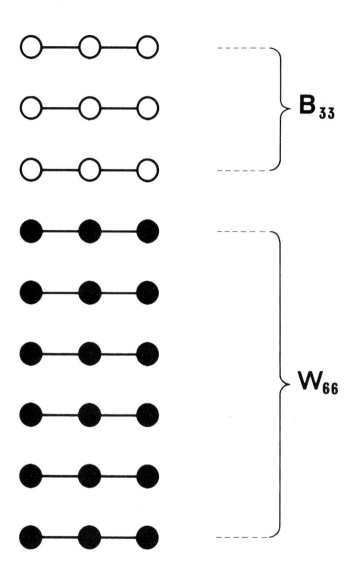

15 Group formation leading to achromatic quantity components

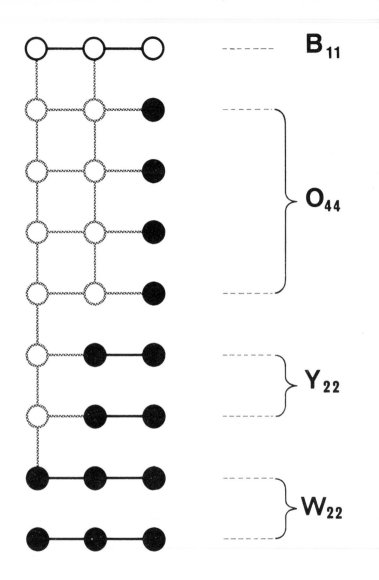

16 A maximum of four quantity components will result from group formation

Anyone who so desires can also make nine additional circles for each of the eight basic colors in order to make the basic color visible on the right, next to the diagram for each group.

Prepared in this fashion, now turn to fig. 14, which shows the "statistical quantity picture" for hue 00 99 22. It consists of groups of two of the primary colors G and O, which lead to the portion Y_{22}. Moreover, only individual quanta of the primary color G are here, as "bachelors," so that the portion G_{77} results. This makes a total of 99 basic color quanta.

Fig. 15 shows the statistic quantity diagram for the achromatic hue 66 66 66, which is a light gray. Here we find only groups of three and "unoccupied places." Thus the portions of the two achromatic basic colors, that is, W_{66} B_{33} result.

Fig. 16 shows an entirely "normal" hue such as we encounter in the overwhelming number of cases: no primary color is missing, but on the other hand none completely fills out the possible potential. This hue, with primary color code number 22 44 88, thus consists of groups of three, groups of two, individual quanta, and unoccupied places. Hence we get the portions W_{22} Y_{22} O_{44} B_{11}.

Findings: The "statistical quanta diagram" explains the group formation of primary color quanta and shows how basic color quanta originate. This makes it possible to clearly explain the transformation of a primary color code number into a basic color code number.

§ 16 The 99 Basic Color Quanta of a Hue (The Primary and Basic Color Quantity Model)

A hue always consists of 99 basic color quanta, independently of the number of primary color quanta involved.

As we have said, we always consider the individual hue to be the product of the visual system's output unit, to be *one* sensation from among the vast number of possible color perceptions.

In the preceding chapters we have learned that every hue can always be illustrated by 99 basic color quanta, regardless of the number of participating primary color quanta. We know that the basic color quanta of a hue can come from a maximum of four basic colors belonging to one of the six possible basic color groups. We also recall that the basic color W and the basic color B are represented in each group so that, moreover, only quantities of two chromatic basic colors located next to each other are possible.

To demonstrate this situation, we have become familiar with several possible illustrations up to this point: the "mechanical model for the explanation of the origin of sensation in the human visual system" (color fig. 9), the mathematical and graphic illustrations (figs. 8-11), and the "statistical quanta diagram" (figs. 13-16).

The "primary and basic color quantity model" is yet another manner of illustration, whose advantage resides in the fact that it makes the quantitative relationships "tangible" in the truest sense of the word and thus makes them easily understood.

Demonstration:
Four perpendicular rods mounted on a wooden board
99 identical slip-on rings or 99 wooden cubes or blocks
Oil paints in the eight basic colors or colored paper [G] for gluing on

This type of "primary and basic color quantity model" can be seen in color fig. 8, where the quantitative relationships are rendered visible and graspable in a three-dimensional fashion. The model, on the primary color side, consists of three perpendicular rods placed close together and attached to a base. Each rod is as high as nine slip-on rings placed on top of each other. The nine rings for each rod on the primary color side are colored violet-blue, green, and orange-red.

Thus each individual ring again represents a "packet" of 11 primary color quanta. In this way we can again illustrate the codes of 1,000 hues on the primary color side with the help of this model.

On the basic color side (on the right) there is only one rod, on which we can likewise slip only nine rings. Because here again the individual ring must be construed as one "packet" of nine basic color quanta, in the case of the nine rings we are dealing with 99 quanta (9 x 11 = 99).

For the rod on the basic color side, however, nine slip-on rings are available for each of the eight basic colors. This gives us a total of 72 rings for the basic color side, to which we add the 27 rings for the primary color side. We therefore need the following rings for the model:

W = 9 each
Y = 9 each
M = 9 each
C = 9 each
V = 18 each
G = 18 each
O = 18 each
B = 9 each

99 total

56

The four examples in color fig. 8 show how to obtain, on the primary color side, a quantitative illustration of the primary color code number, in other words, the codes. On the right, on the basic color side, the basic color portion formation is derived. In this way, the correlations between the primary color code number and the basic color code number become clear.

Color fig. 8 A illustrates the hue 99 99 99, i.e., ideal white. On the primary color side, all nine rings are present for primary color V, primary color G, and primary color O. The basic color side here consists of nine white rings.

For the hue 99 00 44 we get the arrangement in color fig. 8 B. The basic color code number $M_{44} V_{55}$ now develops because we are dealing with a hue that was neither whitened nor blackened.

Color fig. 8 shows how the portions of the achromatic basic color W result if equal quantities of all three primary colors are present on the primary color side. The primary color code number 77 99 33 leads to a basic color code number $W_{33} C_{44} G_{22}$.

Finally, in color fig. 8 D we find the primary color arrangement that we have referred to as the generally normal one. None of the primary colors completely uses up its potential here. At the same time, however, none is completely absent. Thus we can see the transformation of the primary color code number 22 55 88 into the basic color code number $W_{22} Y_{33} O_{33} B_{11}$.

Of course, the same clear view of the situation can be achieved in a simpler manner than the one described here by using cubes or blocks instead of the rings that can be slipped onto the rods. The cubes or blocks can simply be stacked on top of each other. As a rule we must only ma e that, on the primary color side, there will be no more than nine little blocks for any primary color, whereas on the basic color side, there must always be nine.

Such rectangular bodies can be made, for example, from wooden blocks. They also offer the advantage that colored paper [G] can be glued on them without difficulty. Unfortunately, the proper oil paints for painting the little wooden blocks in the eight basic colors are not available or can be obtained commercially only with the greatest difficulty. This applies particularly to the colors cyan-blue and magenta-red. If necessary, one can improvise by putting the printing inks cyan-blue and magenta-red on top of white oil paint.

This primary and basic color quantity model is an extremely interesting educational manner of illustration. The volumes are visible as exchangeable parts and are easily understood as quantity portions. It is made clear how the basic color portions are to be derived from the primary color code. The resultant basic color code number would constitute the correct formula for the subsequent mixing of the hue with opaque media if the latter were available with the necessary ideal properties.

Findings: The primary color code number and the basic color code number of a hue are in strict relation to each other. A primary color

code number can easily be transformed into a basic color code number. It is equally simple to derive the corresponding primary color code number from a basic color code number.

§ 17 The Three Perception Forces as Vectors (The Folding Vector Model)

To illustrate the principles of vision geometrically, we consider the primary colors to be vectors. Depending upon their angular position with respect to each other we get the geometrical shapes represented by the hexagon, the cube, the rhombohedron, and the straight line.

A vector is the physical term for a force that works in a certain direction. The physical law of forces on a parallelogram applies to the combined effects of two or more vectors if they work from the same point of origin.

In fig. 17, force **a** works in the direction indicated by the arrow. Its point of departure x is the same as for force **b**, which works in a different direction. Both forces "pull" on point x—in other words, they relate or refer to x. As the combined new force we now get vector **c**, which we call the "resultant." By virtue of the combined forces **a** and **b** we get **c** as a new force. The position of the terminal

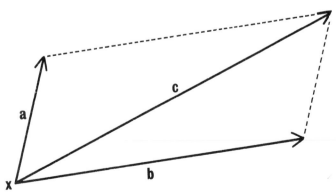

17 The law of forces on a parallelogram

point of **c** emerges geometrically with the help of the broken lines running parallel to **a** and **b**; fig. 17 demonstrates the principle of the law of forces on a parallelogram.

In the preceding considerations we examined the law of vision from various perspectives. The functional principle according to which the visual system works was explained mathematically, geometrically, and statistically. The theory of quantity was also very helpful to us in this explanation.

We now switch to the field of geometry, because it enables us to simultaneously illustrate the totality of all hues with clear models and arrangement patterns.

The reader will recall that we initially described the primary colors as the visual system's three perception forces. In geometrical terms it is a good idea to illustrate these forces as vectors.

We have no reason for assuming that the three primary colors, which we are now considering as vectors, differ from each other in terms of their valence and their importance. Obviously, they have equal rank and hence must also be considered as having equal rights. This is expressed geometrically by illustrating them as being of equal length. Accordingly, we now only need to answer the question as to the angle at which the vectors must be arranged with respect to each other.

If we start with three vectors at the zero point black (B) at angles of 120° with respect to each other, they will lie on the same plane. According to the law of forces on a parallelogram, they form a hexagon. This hexagonal surface consists of three rhombi, one of which can be seen in fig. 18 A.

If the angle is 0°, as in fig. 18 D, all three vectors will be on the same line, which represents the achromatic scale. Because all three vectors start from the same point and lead to the same point, they have been "synchronized." Now only achromatic values, that is, gray shades, can develop.

Any angular position other than 120° and 0° will lead to three-dimensional geometrical shapes, called parallelepipeds. Any desired three-dimensional geometric shape that serves to present an arrangement of hues is called a "color space" or "color solid." (This applies not only to parallelepipeds but also to the trihedral pyramid, the sphere, the double cone, etc.)

The color hexagon and the achromatic scale assume special significance as the simplest geometric patterns for color theory, as

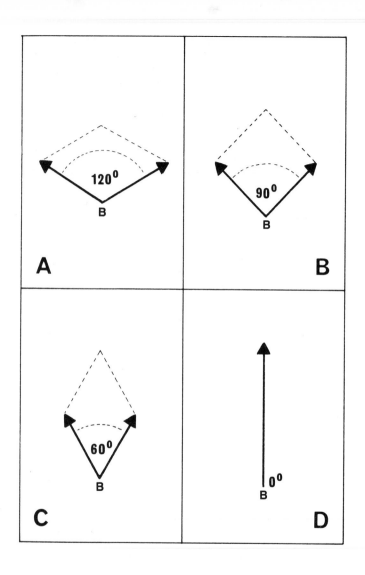

18 The four angular positions of the vectors

we shall see later. Because in the case of these geometrical arrangements we are dealing however with two-dimensional and unidimensional forms, respectively, it is impossible to use them to illustrate the arrangement of the totality of all colors. The three vectors (primary colors) require a three-dimensional model for the geometrical illustration of all possible variations. Each vector represents one dimension here.

In the search for the optimum geometrical illustration in the form of a color space, there must be no arbitrary procedure and no approximations. There can be no room here for individual freedom of design. In other words, if we illustrate the forces of the primary colors geometrically as vectors and if, moreover, we allow the shape to result from the law of forces on a parallelogram, we will always obtain parallelepipeds with equal outside edges. The only question is which angle is meaningful, or in other words, "correct."

The answer to this question becomes clear as we look at figs. 18 B and C. Only the angles of 90° and 60° come under consideration. The 90° position gives us the cube shape and for the 60° position we get a rhombohedron.

We will cover the consequences of these four angular positions of the vectors in detail as we go on. The positions illustrated in fig. 18 A-D are of particular significance in color theory, as they are best suited for explaining the system behind the law of vision in geometrical terms.

Demonstration:
12 identical straws or little wooden rods
Nylon thread or twine, glue [K]

To illustrate the geometrical interrelationships just described in a three-dimensional manner, build a folding vector model whose purpose is to demonstrate that only the angular positions shown in fig. 18 A-D can be a meaningful approach.

Fig. 19 shows photos of the corresponding four positions of the folding vector model. The model shown here, naturally, is a rather expensive version. The rods representing the three vectors are attached to a block of wood so that they can be moved only vertically by means of hinges. There are insertable and exchangeable gray axes both for the cube shape and for the rhombohedron shape on which there is a head piece into which—in the correct angular position—the three corresponding rods can be inserted.

In addition, there is a color hexagon surface for this model which, as we can see in fig. 19 A, serves as the point of departure for the geometrical

A **B**

C **D**

19 The folding vector model in the four positions A, B, C, and D

transformation. This, of course, makes the model more interesting and the interrelationships more readily understandable.

Of course, not everyone can or wants to expend the cost and the labor needed to make the most perfect version of this hinged vector model. Nor is this necessary, because it is possible to provisionally do the same basic thing in the most elementary fashion with 12 straws loosely connected with thread at the ends. This can be done by piercing the ends of the straws with a needle. Or you can push the thread through the straws with a thin wire and then knot them together. In this way this geometrical transformation can be demonstrated in a very clear manner. Now carefully hold the three tied-together straws (black dot in the model) representing the three vectors with one hand. With the other hand grasp the three straws that form the tip (white dot in the model) and pull them up for a corresponding interval. You can use your fingers here to correct the angle positions. Thus it is possible with relatively little trouble to illustrate the interesting geometrical transformations in a three-dimensional way by beginning with the hexagon lying on the table.

Findings: There is a geometrical transformation that leads from the hexagon via the cube and the rhombohedron to the straight line. These geometrical shapes are formed according to the law of forces on a parallelogram.

20 A folding vector model made of 12 straws

§ 18 The Achromatic Arrangement on the Achromaticity Line

The achromaticity line is the systematic arrangement of all achromatic hues.

The achromaticity line, which we also call the "gray axis" or "achromatic line," is the straight connecting line between the achromatic basic colors white and black. We must visualize this achromatic scale as a continuous sequence of an infinite number of achromatic shades (gray hues) arranged between the two terminal points of that line, the basic color W and the basic color B.

Hence, all achromatic hues are systematically arranged on the achromatic line according to their brightness.

In our primary color code number system, we get 100 hues on the achromatic line, which we can designate as follows: for example, 00 00 00, 01 01 01, 02 02 02, etc., up to 99 99 99. Some of the important shades are entered with primary color code numbers in column A of fig. 21. In column B, the black dots indicate the position of these hues on the achromatic scale. Next to the dots are letters indicating various hues. In addition to W for white and B for black we find L for "light gray," N for "neutral gray," and D for "dark gray." These three new names for achromatic hues with a very specific mixing ratio, as we will see later, are particularly important for the "law of gray mixing."

Column C, containing the pertinent basic color code numbers, illustrates what we call the "quantity exchange." Each hue of gray, naturally, is nothing but a certain mixing ratio between the two achromatic basic colors white and black. If we mathematically start with the idea that each basic color is made up of 99 quantity units (quanta), then one quantum of one basic color can be added to the mixture only if a quantum has "made room" for the other basic color beforehand, if it was taken away. This is because the sum of 99 basic color quanta is unalterable for each hue in this manner of computation (mathematical quantity $1 = 100\%$).

Of course, the pertinent basic color code numbers also constitute a continuous series from point B to point W. This happens in a manner similar to the primary color code numbers, except that the number of participating basic color quanta always leads to the sum of 99. This series begins at the bottom at $B_{99} W_{00}$, continues via $B_{98} W_{01}$, $B_{97} W_{02}$, $B_{96} W_{03}$, etc., all the way to $B_{00} W_{99}$.

A	B	C
99 99 99	W	W99 B00
75 75 75	L	W75 B25
66 66 66		W66 B33
50 50 50	N	W50 B50
33 33 33		W33 B66
25 25 25	D	W25 B75
00 00 00	B	W00 B99

21 The arrangement of achromaticity hues on the achromatic line

In the quantity exchange described, we become acquainted with a system that will be important later when we are dealing with the practical application of color mixing laws. Whenever we deal with opaque colorants that must be mixed first and then applied in one color layer, we are dealing with the principle of quantitative exchange.

If, for example, we had the two achromatic basic colors white and black available as opaque oil paints coordinated with each other with respect to their color strength, etc.—we could perform the thorough mixing of all hues on the achromatic line in a purely quantitative manner by weighing or measuring the volumes.

As we know, achromatic color perceptions come about by virtue of the fact that the three perception forces of the visual system, that is, the three primary colors, are synchronized. From a geometrical point of view they thus run together from point B to point W on the same line. The angle between them is of course 0° here.

Physiologically, the "gray" sensation naturally can only be produced if the particular color stimulus differs in intensity from the "white" general illumination and if adaptation has thus been rendered impossible.

Demonstration:
Gray continuous tone film, at least 13 x 18 cm, 18 x 24 cm is better [H]
Light box

Obtain a so-called "continuous tone film" whose density, if possible, should not exceed a value of 0.3. The term continuous tone film is used for a film sheet on which the gray impression does not result from little black screen dots, but rather from genuine gray values. By the term "density" we mean the degree of blackening (opacity). The higher the density value, the less light is allowed to pass through. We do not expressly want to go into the logarithmic interrelationships here. For the moment it is important for us to know that if we have a density value of 0.3, half of the light will be allowed to pass through. (The other half naturally has been absorbed.)

Take the film sheet and cut out 10 or 12 rectangular pieces as shown in fig. 22. Lay the strips on top of each other in a staggered arrangement, as shown in fig. 23. Because the continuous tone film has a density of 0.3, each step will now allow half of the light of the preceding one to pass through. We now get a logarithmic series for the intensity of color stimuli. This is because, on the illumination surface of the light box itself, the color stimulus has the value $\frac{1}{1}$, on the film step it is $\frac{1}{2}$, followed by $\frac{1}{4}$, $\frac{1}{8}$, $\frac{1}{16}$, etc. This corresponds to the density value 0.0 for the luminous surface. The first step has the density value 0.3, the second one 0.6, the third one 0.9, etc.

0.3	2.1
0.6	2.4
0.9	2.7
1.2	3.0
1.5	3.3
1.8	3.6

13 cm

18 cm

22 Cutting a continuous tone film into strips

In the case of the intensity of color stimuli we are dealing with logarithmic relationships; on the other hand, the density appears as an arithmetic series. Densities of 2.7 or 3.0 or more are perceived as "black."

The density values that arise when these pieces of film are superimposed in the manner described are entered in the boxes in fig. 22. The staggered superimposition is illustrated in fig. 23 in a somewhat shifted manner so that the individual pieces can be seen. In this figure we can also see that when we use pieces of equal size, we are moving "up the stairs" on the one side and "down the stairs again" on the other side.

This experiment is considerably more effective if you take the trouble to cut the film strips into different sizes, in which case the stairs go only "upward." Fig. 24 shows how to proceed with the cutting. The 13 x 18 cm film sheet is subdivided the long way into three equally wide strips. If we then, for example, select a step width of 4.3 cm, we can bring out the nine designated steps, which give us a density of 2.7. We are then left with a 9-cm

23 Staggered superimposition of strips

24 Structure of achromatic stepladder

piece. It is interesting to place it over the "stairs" so that each step
covered, in order to observe how the individual steps change in the p
In this way we get a density of 3.0 on the last step, which the visual
naturally identifies as black. But we recognize that the differences become
smaller the further we move up on the stairs. Hardly any difference can be
detected visually between steps 2.7 and 3.0.

If you have a film sheet with a density of less than 0.3, you must make a
correspondingly larger number of strips.

Findings: Gray hues are perceived if, in case of unchanged
surrounding illumination, the color stimulus comes about through a
reduced radiation intensity of white light.

§ 19 The "Rhombohedron"—The Ideal Color Space
The rhombohedron represents the ideal color space.

The rhombohedron is a geometrical three-vector model. Each
primary color—in other words, each perception force of the visual
system—is represented by a vector. Because the vectors are
considered to have equal value and equal importance among each
other, they are of equal lengths. The angles between them in each
case are 60°.

The arrangement in this color space derives directly from the law
of forces on a parallelogram. Each geometrical point in this space
represents a hue and thus a color sensation. The position of each
point corresponds to the primary color code number of the
particular hue. By means of the three vector values, which can be
read off from the three groups of digits in the primary color code
number, each individual hue is assigned its particular place
according to the law of forces on a parallelogram.

Hence, the rhombohedron system is the geometrical illustration
of the law of vision. This crystal-clear geometrical shape is also the
geometrical illustration of the working principle according to which
the visual system goes into action and of all the sensation
possibilities that it can produce. This is why color mixing laws can
also be clearly explained by means of the rhombohedron. Each
individual color mixing law can only be one possible interpretation
of the law according to which the visual system works. Because we
can derive the regular interconnections between color origin, color
mixing, and color sensation directly from it, we must consider the
rhombohedron as the "ideal color space."

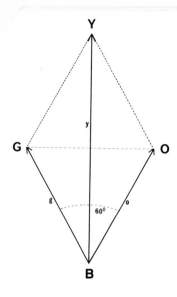

25 Angle position of 60°
between vectors
G and O

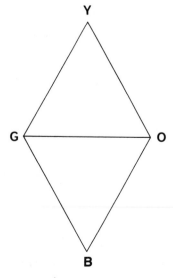

26 The shorter rhombus
diagonal is the length
of one side

Fig. 25 clearly shows how we obtain the resultant **y** from the vectors **g** and **o**. Because **g** and **o** are of equal lengths and because the angle between the two is 60°, we obtain a rhombus whose short diagonal is as long as its side by the virtue of the law of forces on a parallelogram. This is why it can be broken down into the two equilateral triangles in fig. 26.

We also find the explanation for the 60° angle position of the vectors in the ideal color space here. Because black differs from green just as much as it does from orange-red and because, on the other hand, orange-red differs from green just as much as it does from black, it is only logical that the segments BG, BO, and GO should be of equal lengths.

What we said about the lower triangle in fig. 26 also applies to the upper one: yellow differs from green just as much as it does from orange-red. Green differs from orange-red just as much as it does from yellow. These three colors likewise are located at the apex of an equilateral triangle.

The segment between B and Y, on the other hand, is longer, because these two basic colors are not located at the corners of the same equilateral triangle.

The heavy steel door of a bank safe can be opened with great ease if the correct combination of numbers has been dialed in the lock. This situation seems very similar to the angular adjustment of the vectors in the formation of a color space. At 60° we get the rhombohedron color space which we can break down into its "subsystems" in the very simplest way. In color figs. 10 A and B we see the rhombohedron from two different sides. In color fig. 10 C it can be broken down by means of two corresponding cuts into three new geometrical solids, each of which is in itself completely symmetrical: two tetrahedrons and one octahedron. Each of these new solids is a new color space which in turn represents an individual color mixing law. We will come back to this later.

Because the rhombus BGYO in fig. 27 is formed by the two vectors **g** and **o**, we find all the possible variations of these two primary colors in it. The points have been plotted for the two hues H_1 and H_2. The broken lines show how their position is determined according to the law of forces on a parallelogram. The primary color percentage values can be read off from the scales on the particular rhombus sides. Thus hue H_1 is matched up with primary

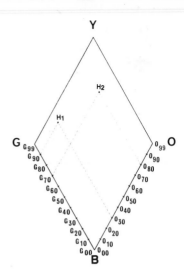

27 Determination of vector
intensities for two points

color code number 00 90 30. In the case of H_2 we are dealing with
the hue 00 70 80.

It is clear that we need three dimensions to illustrate the possible
variations of all three primary colors according to the same
principle. This is shown in fig. 28. The rhombus BGYO from fig. 27
now stands perpendicularly and on the left forms an outside of the
color space. Vector **v** is placed at point B so that it too forms an
angle of 60° with the other two vectors. This third vector turns the
rhombus into a rhombohedron.

In fig. 28 we realize how we must consider **w** as the resultant of **y**
and **v**. At the same time, however, **w** is the resultant from **m** and **g**
and also from **c** and **o**.

This perpendicular outside surface BGYO in fig. 28 is a "primary
color quantity plane" (PriQP). Specifically, we are dealing with
primary color quantity plane V_{00} here. That is to say, all hues that
do not have a quantitative value of the primary color V are arranged
here. This includes all those hues in whose primary color code
number the first two digits are zeroes.

Cuts through the rhombohedron running parallel to this outside
surface are primary color quantity planes of V. All hues on this

profile plane have the same quanta number for V. The quanta value of primary color V increases as the interval between the sectional plane and the outside surface V_{00} becomes larger. Fig. 29 shows some of these sectional planes, specifically, at intervals of 11 quanta each. The primary color quantity planes are placed parallel, one after the other, like the slices in a package of sliced bread. They always have the same shape and size. The primary color quantity plane V_{00} in fig. 29 is the reference plane for primary color V. The quantitative value of the hues for this primary color corresponds to the interval between the primary color quantity plane and the reference plane. The largest possible interval is found at primary

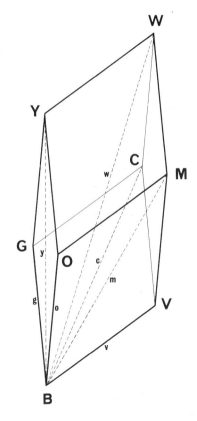

28 The third vector leads
 to the third dimension

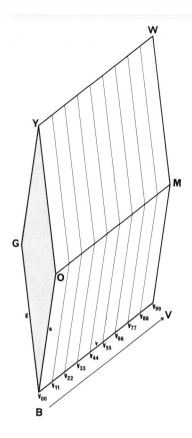

29 Parallel primary color
quantity planes

color quantity plane V_{99}, which is the outside surface VCWM in fig. 28. Each hue on this primary quantity plane has 99 quanta of primary color V and hence has 99 in the first group of digits of its primary color code number.

Let us dwell a little longer on fig. 28. The reference plane for the primary color G is the outside surface BOMV while the one for the primary color O is BGCV. Hence, in the rhombohedron color space we have three different types of primary color quantity planes within each other, that is, they penetrate each other. Each type belongs to a primary color and runs parallel to its reference plane.

We must thus visualize that any desired hue will lie at the point of intersection of "its" three primary color quantity planes. Because one section line develops in each case between two primary color quantity planes, each hue at the same time also lies at the point of intersection of "its" three primary color sectional lines. Here we see the role the quantum theory plays in color theory.

In fig. 30 we see the rhombohedron with the perpendicular achromatic axis WB. This underscores the significance of this line as the axis of the color solid. The achromatic line now becomes the gray axis of the color space.

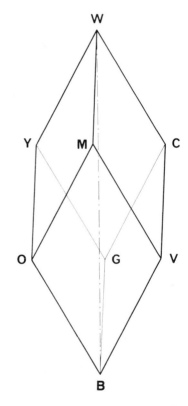

30 Rhombohedron with
 perpendicular gray axis

The achromatic basic color B is at the lower apex of the rhombohedron. This is the point of departure of the system—in other words, the point at which the three vectors that represent the three primary colors begin. When the basic color W is at the upper apex, we reach the terminal point, the conclusion. White means "full capacity" of all three primary colors. The six chromatic basic colors have their places at the six remaining corners of the system, where they are in their extreme position.

Demonstration
Rhombohedron hobbycraft sheet [I] or thin illustration board, paint, and glue [K]

What we want to do here is make a three-dimensional model of the rhombohedron color space, as shown in color figs. 10 A and B. Color fig. 10 B is rotated 180° with respect to A to show the other side of the model.

Making such a rhombohedron, of course, is a very simple thing if you have the hobbycraft sheet. But of course you can also make everything yourself, which makes the entire experiment more informative and interesting. This also offers the advantage of enabling you to determine the size of the model yourself.

First transfer the outline drawing in fig. 31 to the thin white illustration board in the desired dimensions. Of course, you can also work with several parts if you provide additional flaps for gluing at the corresponding sides. The contour drawing can be applied very easily because all sides and all short diagonals have the same length. Measure this length with a protractor and plot the corners on the illustration board by having the protractor circles intersect each other.

In this way you obtain the color arrangement from fig. 30 or color figs. 10 A and B. The hues for the chromatic basic colors should basically correspond to those in color fig. 7; they may, naturally, be purer and more luminous.

It is a good idea to score the edges, which should be bent later, before applying the color surfaces. Otherwise it will be difficult to get smooth bent edges. The scoring can be done with the dull side of a knife or a pair of scissors. Of course, you must be careful not to apply too little or too much pressure. But you can easily test the correct intensity of scoring by using a piece of cardboard (by drawing the knife or the scissors along a ruler and applying pressure).

If you begin with the outline drawing in fig. 31, it is best to glue the flaps one after the other in the numerical sequence given; you should wait in each case until the glue has dried before gluing the next flap, so that it will not be shifted out of position.

The finished model can be "speared" on a knitting needle stuck into a thick cork. But be careful: many needles have broad points, in which case the model should be pushed up on the needle from the other side. In order to be able to stick the knitting needle through, very carefully cut a little bit away from the upper and lower tips of the rhombohedron, using a pair of scissors. Carefully widen the little holes with a pin or a thin nail. The holes must be small enough so that the paper body is fastened on the needle. If the holes become too big, wrap a little piece of adhesive tape around the needle.

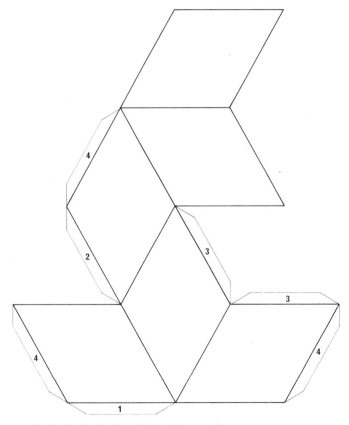

31 Outline drawing for glued rhombohedron model

In working with this rhombohedron model, you can already understand many of the interrelationships present. When the model is finished, you can look at the higher law of vision in the form of ideal color space. This model is not only educational, but also very decorative. If you can muster sufficient diligence and care, you can make an interesting mobile from the various geometrical bodies (color fig. 10), that is to say, from rhombohedrons, octahedrons, and tetrahedrons.

Findings: Each point in the ideal color space of the rhombohedron corresponds to a hue and thus to a color sensation. Its position is determined by the law of forces on a parallelogram.

§ 20 Advantages of the Cube Color Space

The cube color space offers the advantage of square sectional planes. This can be useful and meaningful in making clear color charts.

We know that the primary color vectors cause a cube color space to develop if they begin, as in fig. 32, at angles of 90° with respect to each other, at point B.

This regular, rectangular solid is particularly graphic because it conforms so well to our concepts of the three dimensions represented by length, width, and height. We are also accustomed to such rectangular shapes in our environment—for example, in the form of houses, rooms, parcels, matchboxes, etc.

In addition, we are initially inclined to consider the cube as the simplest three-dimensional geometrical shape. This is not the case, however, because the simplest geometrical shapes are the straight line for one dimension, the equilateral triangle for two dimensions, and the regular tetrahedron for three dimensions—in other words, a body whose outside surface is formed by four equilateral triangles (see color fig. 10 C, top and bottom). The simplest geometrical shapes just listed also constitute the basic structure of the ideal color space.

Naturally, nothing is changed either in the content or in the system of arrangement according to the law of forces on a parallelogram if we move the three vectors into angular positions of 90° with respect to each other in the manner described. The only

difference is that, as we can see in fig. 32 the gray axis WB becomes as long as the chromatic axes YV or MG or CO as a result of the change in angles.

By virtue of the fact that this gray axis (achromatic axis) is shorter in the case of the cube and because of the resultant altered geometrical relationships, we no longer have the fascinating possibility of the rhombohedron, which can be broken down into new, completely symmetrical bodies—that is to say, into one octahedron and two tetrahedrons. We also lose the possibility of illustrating how the corresponding color mixing laws are actually subsystems of the rhombohedron system. The considerably longer achromatic axis of the rhombohedron also better accommodates the visual interval perceptions between hues.

The disadvantages of the cube compared to the rhombohedron are countered by its advantages: on the one hand, the rectangular relationships are more easily understood and, on the other hand, we have square sectional planes, which naturally lead to clearer

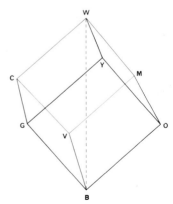

32 Cube with perpendicular gray axis

color charts. To be sure, this advantage exists only if one wishes to draw up color charts that refer to the starting colors used in a purely quantitative manner. And this will probably make sense only if one has three transparent filter layers available in the colors Y, M, and C, as is the case both in color photography and in normal multicolor printing. Hence the cubic shape presents no advantages at all when the hues are to be arranged according to quality characteristics—in other words, their chromatic types (chroma), achromatic value (saturation), and brightness. (The terms in parentheses above unfortunately are still used frequently for the concepts that are meant, although they can be easily misunderstood.)

The rhombohedron color space, naturally, is primarily an ideal image, a Utopia. For technical reasons it is impossible, nor will it probably be possible to "correctly" reproduce the sectional planes by means of this color body. This appears to be impossible because, after all, we are dealing here with an arrangement of all color sensations, and we know from our initial experiments that we cannot fix color perceptions or illustrate them precisely in terms of the material involved. Whenever we are dealing with material, we also encounter the complex problem of the spectral composition of illumination light and the adaptation processes in the visual process, which we have examined in the form of achromatic and chromatic adaptation. In addition, we have other effects, such as simultaneous contrast, etc.

For the reasons described, the rhombohedron is the most suitable geometrical shape for explaining the law of vision. The interrelationships between color origin, color mixing laws, and color sensation can be clearly explained and derived from it; the rhombohedron is primarily a thinking model.

On the other hand, we can effectively use the advantages of the cube in order to demonstrate reality. This color space is particularly clear and instructive for working with so-called "trichromatic systems."

The term trichromatic processes is used in referring to technologies in which three chromatic colorants are varied in terms of "quantity." This is the case not only with color photography and ordinary multicolor printing, but also in color television and, in some instances, in textile dyeing and recently even in connection with methods for mixing paints. In trichromatic processes achromatic values result mainly from the fact that the initial

chromatic colors neutralize each other. But we will take up this group of topics in detail when we discuss color mixing laws.

At this point we merely want to show how useful the color cube can be in illustrating the special, process-dependent possibilities and limitations of color reproduction of a certain trichromatic process in a quantitative order. Let us take everyday multicolor printing as an obvious example (of which this book is practical proof). In multicolor printing we have available the chromatic printing inks yellow, magenta-red, and cyan-blue as transparent filter layers. The surface of the white printing paper represents the achromatic basic color white here. Quantitative values of white result and blend into the mixture wherever the residual surfaces of the paper are not covered by a color layer.

Fig. 33 shows the quantitative structure of the square starting surface that ultimately leads to the cube. The value for magenta-red is indicated on the scale on the left and the value for cyan-blue is indicated on the scale below. The data refer to the percentage values of surface coverage of the screen in the copying film.

In this color chart we thus show the possibilities of mixing the printing inks magenta-red and cyan-blue; yellow is not represented here. This is why the chart value for yellow, shown above the upper left corner, is Y_{00}. This value applies to all of the hues in this table.

In this arrangement we have chosen an interval of 10 % between hues. We thus get 11 steps for each printing ink, so that we have 121 hues in one chart. (In the case of yellow we are also dealing with increments of 10%. We thus obtain 11 charts with a total of 1,331 hues [L].)

In the initial chart in fig. 33, we have a basic color at each corner of the square, that is to say, W, C, V, and M. The basic colors obviously do not correspond to the ideal concepts; they are as good as they can be reproduced in this process.

In chart Y_{99}, the full color layer yellow is placed over each hue of this initial chart. Thus W becomes Y, C becomes G, V becomes B, and M becomes O. This brief explanation shows how we can manage to reproduce the color space with the available three chromatic transparent filter layers. The three filter layers cooperate in terms of their absorption capacity. The residual values of the white paper surface remain effective and are blended into the mixture as differential value. Of course color reproduction,

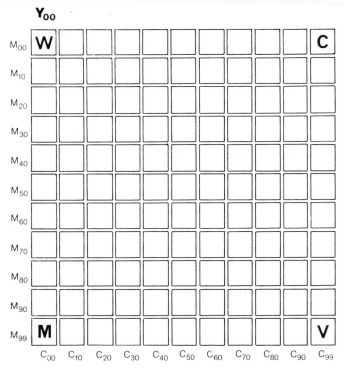

33 Systematic arrangement of the mixing possibilities of two inks

compared to the ideal color space, is restricted by the absorption and reflection flaws of the printing colors.

We can easily read off the code number for each of the 1,331 hues. First we take the chart value, i.e. the quantitative value of yellow, and then we take the left-hand scale value, in other words, the quantitative value of magenta-red, and finally we take the lower scale value, which gives us the quantitative value for cyan-blue. For this particular hue, we get, for example, the code number $Y_{20} M_{90} C_{70}$.

This code number must under no circumstances be confused with the primary color code number. It relates to colorant quantities of an individual process and is thus subjective. If we print the color

charts, for example, according to the U.S. Standard Offset Color References, it should be called the "U.S. Standard Color Code." If we print them with the "European Scale," it should be called the "European Standard Color Code." If we use the Kodak scale, it can be called the "Kodak Color Code."

Because the names for colors in a language always cover large color areas and are used in relative terms, it is impossible, in words, to converse or communicate precisely about hues. This is why the "U.S. Standard Color Code" and the "European Standard Color Code" have a good chance of prevailing as communications systems. They, too, can be used in designating a million hues. Because they relate directly to printing, they are practical. Hence, this type of color code not only provides meaningful "names" for each hue, but also practical mixing formulas.

Demonstration:
Color charts [L]
Medium-heavy illustration board
Glue

Make a cube model (color fig. 11 A and B), using the color charts [L] taken from the *Color Atlas*. Mount charts Y_{00} and Y_{90} on cardboard and cut them out neatly, so that there is no white margin left around them.

Using cardboard, glue together a cube that is open on one side. Take narrow cardboard strips to make guide rails on the inside so that the charts, which have been glued on and cut out of cardboard, can be inserted on them into the cube space like drawers. Chart Y_{00} goes on the bottom of the cube, followed by Y_{10}, etc.

It is very easy to make this model. You must merely make sure that the opening of the inside space is neither too narrow nor too wide. The play between the inserted charts and the cube walls should be no more than 0.5–1 mm. Use cardboard with a thickness of 1–2 mm for the guide rails, depending on the available play. The bottom and the top of the cube-shaped box should be 0.5–1 mm wider than the "drawers." In the case of the other three cube walls, you must add the corresponding cardboard thicknesses to the dimension. First glue the cube together from the pieces of cardboard and then cover it with white paper, to make it stronger and so that it looks neater. Only then glue the corresponding charts on the outside surfaces. One of the charts must be cut into strips and "turned around" during the process of application. You can find the appropriate matchups and assembly procedure by first gluing chart Y_{99} on the surface of the cubic box and placing chart Y_{00} in such a manner that you can recognize which basic color belongs on which corner. In this way it is easy to find the corresponding arrangement for the remaining outside surfaces.

Findings: The cubic color space is particularly suited for showing the mixing possibilities for a specific "trichromatic" process in a systematic quantitative arrangement. This applies especially to multicolor printing because it offers an opportunity to obtain reasonably priced and practical color charts in a simple manner through the systematic matchup of screen values. The percentage values of surface coverage in the litho film become the code number for the individual hue. This code number is both the "name" and the mixing formula for the particular hue.

§ 21 The Hexagonal Plane

The surface of the color hexagon shows the two-dimensional arrangement of colors.

It has already been explained that a hexagonal surface is obtained when the three primary color vectors are arranged at angles of 120° with respect to each other at point B so that they lie on the same plane, as shown in fig. 34.

The dimension of the achromatic axis has been eliminated by this geometrical situation. It has been, so to speak, "squeezed together" into a geometrical point, like in a photograph, in which

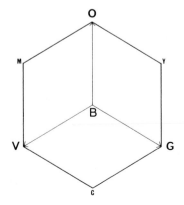

34 The hexagonal surface
develops with vector
angles of 120°

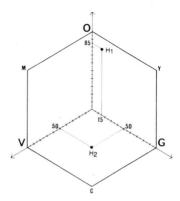

35 Determination of vector
 values for two points

three dimensions are reproduced on a flat surface. In a photograph
we get flat reproduction by virtue of the fact that one dimension is
eliminated, specifically, the dimension in the direction of the
optical axis.

Fig. 35 illustrates how the law of forces on a parallelogram also
applies to the surface of the color hexagon, which necessarily gives
us a quantitative arrangement. Let us take the hue 00 15 85 as an
example. It is assigned spot H_1 by virtue of its 15 quanta of primary
color G and 85 quanta of primary color 0. This is the point of
intersection of the two parallels running along the vectors involved.
The place for hue 50 50 00, on the other hand, is point H_2.

However, we are generally dealing with hues that have quanta
values from all three primary colors, for example, 70 44 87. We can
see in fig. 36 how the place for that hue is specified according to the
law of forces on a parallelogram as well. By virtue of the 70 quanta
of primary color V and the 44 quanta of primary color G, we
determine the auxiliary point H, as the resultant. The broken lines
show the parallels with respect to the two participating vectors. As a
result of the added 87 quanta of primary color 0, we now get point H
as the place for hue 70 44 87 as indicated by the dotted lines.

The perpendicular intervals between one point and the nearest
hexagon side correspond to the achromatic value of the hue in
question. For point H we get, purely geometrically, the achromatic
value A_{56}, which however can be derived mathematically just as
precisely from the primary color code number. This is because the

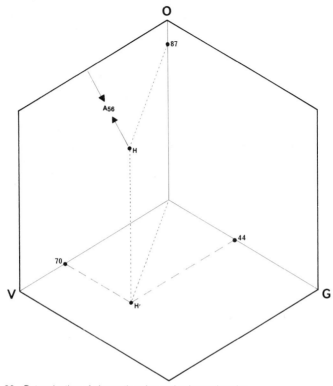

36 Determination of chromatic value and achromatic value

greatest common quanta value of hue 70 44 87 is 44, which gives us the portion for the achromatic basic color W. The difference between the greatest existing value, that is, 0_{87}, and the greatest possible one, that is, 0_{99}, gives us a quanta value of 12 as the portion for the achromatic basic color B. If we now add the two portions of the achromatic basic color, in other words, 44 and 12, we get the same achromatic value, A_{56}.

The individual geometrical point on the surface of the color hexagon, however, does not represent one specific hue, as does the individual point in the color space. Instead, the individual point on the hexagon surface represents a group of hues. This is because the arrangement of this hexagonal surface, after all, is an abstract one.

We obtain the hexagonal surface if we remove the achromatic dimension from the color space, that is, if we abstract this dimension. The individual point represents a group of hues of identical chromatic value, whose quantitative relationship of the two chromatic portions also remains the same. They thus differ from each other only in that their achromatic value can, as desired, be filled out by W or B or by a mixture of W and B.

Fig. 37 makes this situation clear. In contrast to fig. 34, the center is now designated with A, not with B. This A represents the entire achromatic quantity, regardless of what portions of W and B it may be made up of. Any gray shade, or more precisely, any point on the achromatic line, can be used to fill out the achromatic value A.

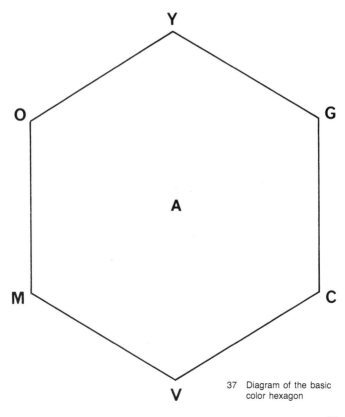

37 Diagram of the basic color hexagon

```
Pentagonal array of letter-number symbols (Y, O, U, M, V),
each subscripted with paired two-digit numbers. Corner labels:

          Y99  (top)
  O99 (left)            U99 (right)
  M99 (lower left)      V99 (lower right / bottom)

Edge Y–O (upper-left):
  Y99
  Y90 O09
  Y81 O18
  Y72 O27
  Y63 O36
  Y54 O45
  Y45 O54
  Y36 O63
  Y27 O72
  Y18 O81
  Y09 O90
  O99

Edge O–M (left):
  O99
  O90 M09
  O81 M18
  O72 M27
  O63 M36
  O54 M45
  O45 M54
  O36 M63
  O27 M72
  O18 M81
  O09 M90
  M99

Edge M–V (lower-left):
  M99
  M90 V09
  M81 V18
  M72 V27
  M63 V36
  M54 V45
  M45 V54
  M36 V63
  M27 V72
  M18 V81
  M09 V90
  V99

Edge Y–U (upper-right):
  Y99
  Y90 U09
  Y81 U18
  Y72 U27
  Y63 U36
  Y54 U45
  Y45 U54
  Y36 U63
  Y27 U72
  Y18 U81
  Y09 U90
  U99

Edge U–V (lower-right):
  U99
  U90 V09
  U81 V18
  U72 V27
  U63 V36
  U54 V45
  U45 V54
  U36 V63
  U27 V72
  U18 V81
  U09 V90
  V99

Interior cells carry three stacked letter-number tokens
(e.g. Y27 O45 U27, Y18 O45 U36, Y09 O45 U45, M36 O27 U36, ...)
filling the field of the pentagon.
```

38 Numerical diagram for basic color hexagon
Note: U (for German *unbuntwert*) = achromatic value (A)

It follows from this that we will find the same chromatic arrangement reproduced on the hexagonal surface in a two-dimensional fashion that is also present in the color space in a three-dimensional fashion. We merely refrained from rendering visible the differentiations that result from variation (due to quantitative exchange) of the portions of W and B in the achromatic value.

The numerical diagram in fig. 38 illustrates this abstract interrelationship. A selection of points is designated with basic color code numbers. The maximum two portions of the chromatic basic colors are given for each point. In this way, the chromatic quantity and the achromatic quantity are defined at the same time. But within the achromatic quantity, the mixing ratio between W and B remains undetermined; any mixing ratio between W and B is possible within the particular achromatic quantity.

We can illustrate this law in an abstract way on the hexagonal surface by means of the numerical diagram in fig. 38; but it cannot be reproduced in this fashion. The possibility of reproduction exists only if we decide to fill out the achromatic value A with a specific real achromatic type. Hence for technical reasons it is a good idea to represent the total achromatic value with white. This is because, in multicolor printing, one simply allows the residual surfaces of the white paper to remain effective, which is what was done in color fig. 12. This method is extremely practical because, according to the numerical diagram in fig. 38, white is automatically left over as the differential value in color printing.

The arrangement in the hexagon in color fig. 12 is the arrangement of what in science are also referred to as "chromaticities", by which is meant the systematic, quantitative arrangement of hues in which the achromatic values are completely filled out by white. Each point on the hexagonal surface is considered as one end of a color series whose other end is always B.

Consistently pursued to the end, this idea would lead to the distorted color space in fig. 39: a regular six-sided pyramid that results if we connect each point on the hexagonal surface with the point B. The advantage of this manner of illustration resides in the fact that, on sections parallel to the hexagonal surface through the solid, we find those hues in which the quantitative ratio between W and B in the achromatic value is constant.

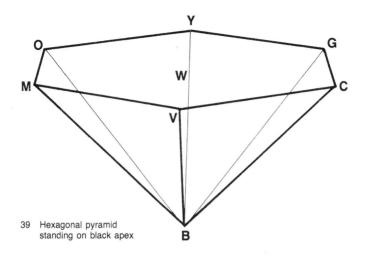

39 Hexagonal pyramid
 standing on black apex

Demonstration:
Medium-heavy cardboard
Thin wooden or metal rod

Make a large cardboard hexagon and color it, as in color fig. 12. It is a good idea to use white cardboard or to mount white paper on cardboard. The most esthetically pleasing and simplest thing is to spray transparent colorants yellow, magenta-red, and cyan-blue on top of each other on this white surface.

Drill holes at regular intervals into this color hexagon; these holes should be big enough so that you can push a thin rod through them. The thin rod itself, which represents the achromatic axis, should be 1½–2 times the length of the hexagon diagonals. You can use a curtain rod, one of whose ends should remain white; paint the other end black. In between arrange the gray shades as regularly as possible. If the colors on the hexagonal surface are blended together in a continuous fashion, the hues on the achromatic line should also blend into one another.

The hexagon and the rod together give us the model in fig. 40. In the position shown, the rod is pushed exactly half way through the hole in the middle of the hexagon. This is the illustration of the hue with the primary color code number 50 50 50 and the basic color code number $W_{50} B_{50}$. The center of the hexagonal surface represents A_{99}, in other words, an exclusively achromatic value. This achromatic value is filled out by the achromaticity (achromatic type here) $W_{50} B_{50}$. In this achromatic hue,

91

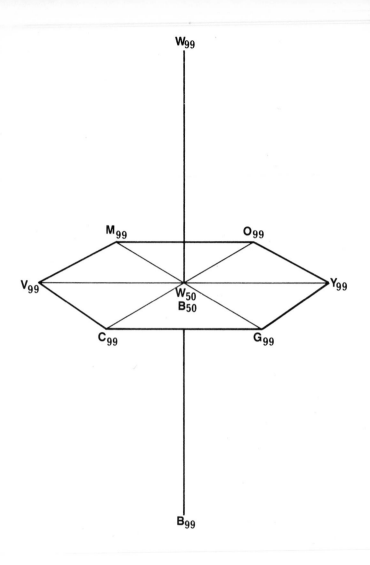

40 The color hexagon as a disk and the achromatic line as a rod

obviously, the chromatic value is equal to zero. The particular hue meant is always located at the point of intersection between the color hexagon and the achromatic axis.

But chromatic values are present in every other point on the hexagonal surface. The greater the chromatic value, the smaller the achromatic value must be. The achromatic arrangement can be seen in fig. 41. The perpendicular interval to the next hexagonal side gives us the extent of achromaticity for the particular point. Hues with the same achromatic value are on hexagon lines running parallel to the outside line. Hues that lie on the outside line itself no longer have any achromatic value. Hence we have a maximum chromatic value here. This is very clear because, on one hexagon side, we have the quantitative exchange between the two chromatic basic colors that are located at its ends.

The achromatic rod can be pushed at different distances through each hole in the hexagon. The portions of the participating chromatic basic colors emerge according to the numerical diagram in fig. 38 from the position of the hole on the hexagon. From the points on the achromatic line we obtain, for the achromatic value, the mixing ratio between W and B, in other words, the achromatic type here or achromaticity. Thus, this model is excellently suited for demonstrating how each hue can consist of a maximum of four basic color portions. And it makes it equally clear that we need a three-dimensional solid—a color space—for the illustrative arrangement of all hues.

If you cannot use spray paint, you can of course coat the rod and the hexagon with a paintbrush. This is only a little more trouble, but the end product does not turn out as well. But you can improve this situation by subdividing the hexagon into equilateral triangles and then coloring each one. In this way, the matchup of the basic color code numbers will be even clearer under certain circumstances. You can enter the code number in the particular color field, as indicated in fig. 38. This can be done directly or with a transparent overlay (Astralon for example).

Naturally it is also possible to make the model just with code numbers. Of course in this case it is a good idea to use a thin strip of wood in place of a round rod and to indicate the quantitative exchange between W and B with basic color code numbers on the strip.

Findings: If we abstract the achromatic dimension, a hexagonal surface develops out of the rhombohedron and the cube, on which each geometrical point represents a group of hues where the portions of the chromatic basic colors and hence the chromatic value, as well as the achromatic value, are equal. That means that for each point on the hexagonal surface only the mixing ratio between W and B in the achromatic value will be variable.

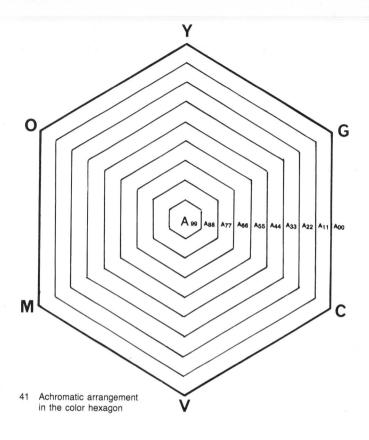

41 Achromatic arrangement
in the color hexagon

§ 22 The Achromaticity Line and the Color Hexagon

The primitive basic schemes of color theory are the achromatic line and the color hexagon.

Anyone who has understood the situation explained so far will have realized clearly that color theory can be simplified to the point where in the end only the achromatic line (achromaticity line) and the color hexagon (chromaticity hexagon line) are left.

The achromatic line is the systematic arrangement of all possible achromaticities. Each geometric point on this scale represents an achromatic step. The position of the points defines the mixing ratio between the two achromatic basic colors W and B for the particular achromatic type hue. The achromatic value of a hue must necessarily be filled out by one of these achromaticities. So we necessarily get a maximum of two portions for the achromatic value of a hue.

42 Achromatic line as connecting line between W and B

Fig. 42 shows the achromatic scale as the connecting line between the two points W and B. The mixing ratios come about by virtue of the fact that a "quantity exchange" takes place between these two basic colors. The quantity portion that is occupied by W cannot be occupied at the same time by B, and vice versa. We always consider the total volume as the mathematical magnitude 1, which is the same as 100%. This is why the quantitative ratio of the two portions is always the mixing ratio for the hue as well.

43 Intervals from H to A and B correspond to the components

What we have said for W and B basically applies to all starting colorants when mixing opaque colors. This is why we designated the two extreme hues in fig. 43 as A and B. The principle of quantitative exchange becomes clear with the help of this illustration. Hue H is a point on the straight connecting line between A and B. Hence we are dealing with a corresponding mixing ratio between A and B. The two portions participating in the materialization of hue H correspond to the two intervals between H and points A and B. The entire segment between A and B represents the quantity 1 = 100%. It is made up of the segments a and b. Regardless of where H is placed on the connecting line, the

A_{99} A_{88} A_{77} A_{66} A_{55} A_{44} A_{33} A_{22} A_{11} A_{00}
B_{00} B_{11} B_{22} B_{33} B_{44} B_{55} B_{66} B_{77} B_{88} B_{99}

44 Quantitative exchange between hues A and B

sum of the two segments obviously is always equal to the total section.

The situation is the same for the developing portions, as we can see in fig. 44. Points on the connecting line are marked at intervals of 11 quantitative units in each case. Where the total quantity is filled out by A, we of course cannot have a portion of B. The further the point moves away from A, the smaller the portion of A becomes. The greatest possible distance is given at point B, where there is no longer any portion of A, since the total quantity is dominated here by B. The further the point moves away from A and the smaller the portion of A becomes, the closer it moves toward B and the greater the portion of B becomes. The sum of the two portions of A and B, however, always brings us to the quanta number 99—in other words, 100%.

The quantitative exchange in the color hexagon in fig. 45 takes places in the same manner. Of course, we are no longer dealing here with the surface of the color hexagon in color fig. 12; instead, we are now concerned only with the hexagonal sides, in other words, the outside line of the hexagonal surface. When a color point is no longer located on the outside line but rather on the surface, we find that achromaticity is necessarily added as a third factor. We call this outside line, where the pure chromatic type hues (chromaticities) are located, the "color hexagon."

The quantitative exchange takes place in the color hexagon basically just as it does on the achromatic line and exactly as shown in fig. 44. Of course, we are now dealing with the straight connecting line between two neighboring chromatic basic colors. Each hexagon side represents all of the possible mixtures between the two neighboring basic colors. The mixing ratio of the participating two chromatic basic colors is defined by the position of the particular point on the particular line. Here we necessarily again get a maximum of two portions of two neighboring chromatic basic colors which together form the chromatic value of a hue.

We can easily read this system off from the numerical diagram in fig. 38 by studying the marginal lines of the hexagon. We also

clearly see how an achromatic value is immediately added when the hue lies not on the marginal line but in the surface area itself. Hence, all chromaticities are systematically arranged on the color hexagon.

Demonstration:
Gray or brown cardboard or particle board
Opaque artist's oil paints in all eight basic colors

Mix the various achromatic hues in accordance with fig. 46. We are proceeding in a purely quantitative manner here. The extreme hues here are W and B, in the form of opaque artist's oil paints. You can achieve the desired quantities of paint, for example, by weighing the portions on a letter

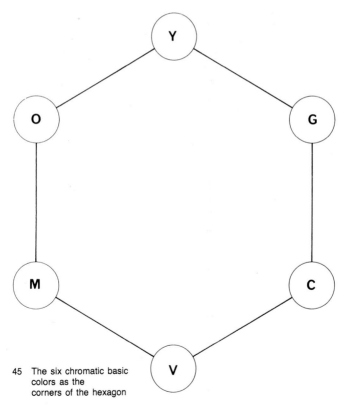

45 The six chromatic basic
colors as the
corners of the hexagon

46 Mixing achromatic type
 hues (achromaticities)

scale. Or you can simply measure the strip squeezed out of the tube with a ruler.

The mixing ratios of five essential achromaticities are given in fig. 46. Anyone who so desires, however, can mix a long achromatic scale with 10 or 20 or more achromatic type hues by following this principle.

In the same manner, mix intermediate chromatic type hues between two neighboring chromatic basic colors according to fig. 47. It is worthwhile to neatly draw a hexagon in advance on the existing base material and to prepare the corresponding field for the hues that you wish to mix. It is best to begin by painting the fields of the six chromatic basic colors. Only one intermediate shade is entered between two basic colors in fig. 47. Depending upon your diligence and desires, you can, of course, mix any number of intermediate shades. Thus the color hexagon is a counterpart to the achromatic line.

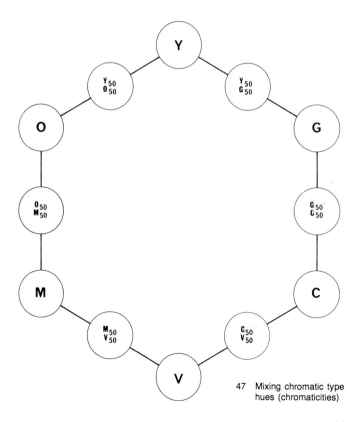

47 Mixing chromatic type hues (chromaticities)

By mixing yourself, you can grasp why a hue basically can consist only of a maximum of four portions. This is because, to the portions of the two achromatic basic colors that form the achromatic value of a hue, we can at most add the portions of two chromatic basic colors, which allow the chromatic value to result.

These mixing exercises should under no circumstances be performed on a white carrier or base material, because in that case the equal significance of the basic color white would not be recognizable. Under no circumstances should these mixing experiments be carried out with tempera or India ink, because those media are generally not coordinated with each other at all. To assure that the mixtures lead to the desired success, the color media used must have roughly the same required opaque capabilities and color intensities. This is best guaranteed when you use artist's oil paints.

You should not be discouraged if magenta-red and cyan-blue cannot be obtained as oil paint in an anywhere near-correct hue. If necessary, you can order these colors directly from a paint factory. The only reason why these two basic colors are usually not found in the available assortment is because they allegedly are "never demanded by the customer."

These mixing experiments can be excellently conducted with suitable powdered colors. The various forms of colored powder should reveal roughly the same pigment sizes. One can render the portions clearly visible by pouring them into different test tubes; specifically, fill the tubes only up to about one-quarter. The principle of quantitative exchange can be explained very clearly if you put the same amount in each time. Mix by shaking. The mixing result is understood to be the result of the quantitative ratio used as a basis.

Findings: Achromaticities (achromatic type hues) are mixing ratios between the two achromatic basic colors. Chromaticities (chromatic type hues) are mixing ratios between two neighboring chromatic basic colors. All achromaticities are on the achromatic line. All chromaticities are on the color hexagon.

Note: The color circle (chroma circle) should no longer be used as a teaching pattern. It should in the future be replaced by the color hexagon, which is better suited to explain the basic interrelationships involved here.

Interaction Between Light and Color Perception

§ 23 "Light" as Visible Energy Radiation

Light is energy radiation with wavelengths between 400 nm and 700 nm.*

Energy rays are electromagnetic oscillations. Sometimes they emerge as waves and sometimes as corpuscles in motion (energy quanta).

The visual system's receiver unit is designed so that it can "catch" very specific radiations from among the manifold supply of energy rays of the most varied wavelengths—in other words, those with wavelengths between about 400 nm and 700 nm.

The energy rays that we call "light" are registered by the smallest receiver cells, which are embedded in the retina of the eye. We are dealing here with the vision cells which we also called cones and rods and whose purpose is to receive the energy of incoming radiation and to transform it into another type of energy, that is to say, electrical impulses in conformity with the visual system. The codes that are passed on via the nerve paths into the brain—where the actual color sensation comes about—consist of those electrical impulses.

We might recall that the spectral composition of the color stimulus does not have a fixed relation to the developing color perception. This was proven by simultaneous contrast as well as achromatic and chromatic adaptation. The visual system allows these correction processes to take place on their own, apparently prior to code formation.

*nm = abbreviation for nanometer; 1 nm = 10^{-9} m = 0.000001 mm.

As we pointed out earlier, we must carefully distinguish between the reception sectors of the cones and the perception powers that are linked to those sectors. In the curves in fig. 48 we have illustrated the three reception sectors in the form of a diagram. Note well: the curves show the reception sectors, not the perception powers. This is because the reception sectors of the cones act as collecting points; vision cells are merely quanta collectors. The particular associated perception power is activated in accordance with the quanta amount collected.

We can best understand the interrelationship between the perceptions power and the reception sector through a comparison. Let us visualize three children who are gathering berries in the woods. Each child has a little basket. Each is assigned his own collection area at a point in the forest full of berries.

The collection area corresponds to the reception sector of the cones. The point in the woods is a long-drawn-out strip that was assigned to the children in segments. Here, of course, the boundary lines are not precisely established. This is why we have overlapping sectors for each of the two neighboring berry pickers. In other words, both pickers will gather berries from the bushes found there and each will get as many as he can in that area. Once a berry is in the basket of one picker it can no longer get into the basket of the other one. These overlapping sectors only exist between the outer areas and the center. Obviously, the two outer pickers do not share a common picking area.

The full baskets are emptied into a bucket. Each child has his own bucket. In our comparison, the buckets are the perception powers. The differing quantity in the buckets is the particular potential used. Each child's picking success is represented by the quantity in his bucket.

We must visualize how the cones work in an analogous fashion. The curves V, G, and O in fig. 48 are the picking areas. Only the "berries" (quanta) that are in a picking area can wind up in the particular "baskets" of V, G, and O. The baskets are very small. They are therefore emptied often when many berries are found on one bush and are emptied more rarely when there are only few berries on a bush.

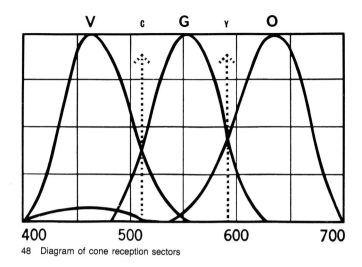

48 Diagram of cone reception sectors

The cones gather the quanta in their sector. But only if a certain quantity has been gotten together (when the little basket is full), do they produce an impulse (the little basket is emptied). A signal is routed into the brain via the nerve paths.

With this example, by the way, we can very vividly illustrate achromatic and chromatic adaptation. Adaptation is performed when, in a certain part of the forest, too many or too few berries are on the bushes. If there are too many, the picking wage for each quantity unit is reduced because there was correspondingly less trouble. But if there are very few, it is increased because, even if one hurries, one cannot achieve a normal output and one thus cannot earn a normal picking wage. Chromatic adaptation would have to be explained in that one picker gets a particularly good picking area while the other one get a very bad one. The quantitative reward therefore is reduced in the case of one of them and is correspondingly raised in the case of the other.

49 Wave scale of electromagnetic oscillations

Demonstration:
Blackboard
Chalk

Draw the wave scale in fig. 49 on the blackboard. First plot only the wavelength data from 1/1,000,000 nm to 1,000 km. This should be done below the scale.

Now draw the arrows above the scale and explain the technical references to the corresponding wavelength sectors. The letters have the following meanings:

A: lethal radiations deriving from an atomic explosion, for example, gamma rays
B: x-rays
C: light
D: heat
E: television waves
F: radio waves
G: electrical current

For instructional purposes, it is a good idea to designate the arrows on the blackboard only with letters and go into the previously explained meaning later (perhaps even out of sequence). The important thing is to point out the rather strange fact that, in this continual scale of various wavelengths, we have that tiny sector from about 400 nm to 700 nm for which the individual has a reception mechanism, that is to say, the eye, which turns those energy radiations into sensory perceptions called "light" and "color."

The visual system's sensitivity does not begin abruptly here. Instead, fig. 50 shows that it rises slowly, reaching a maximum in the area of about 550 nm, and that it then drops down to zero again. We can see in fig. 51 to what extent the light sensitivity curves for daytime vision and nighttime vision differ. The shift during nighttime vision can be explained by the predominant activity of the rods.

The curves in figs. 50 and 51 can be placed on top of the wave scale in fig. 49. In each case they can be drawn schematically with chalk over the corresponding spot on the scale and erased again. It might also be a good

50 Light sensitivity curve for daytime vision

51 Difference in light sensitivity for daytime and nighttime vision

idea to draw the corresponding scale segment, enlarged, over the corresponding spot, so that curves can be drawn larger. In this connection it is naturally also helpful to further understanding if the reception sectors of the three cone types in the form of the curve in fig. 48 are placed on the enlarged piece taken out of the scale.

Findings: The eye is merely the reception unit for the visual system—a sort of antenna system. The vision cells (cones and rods), strictly speaking, see neither light nor colors; they are merely quanta collectors. Visual perception results only as the sensation output of the visual system in the brain.

§ 24 There Is No Color in the Physical World

The physical world is colorless. It consists of colorless matter and colorless energy.

In the physical world there are only matter and energy, both of which are colorless. Living beings with an intact visual system can orient themselves by certain energy rays. They are thus optically in a position to understand their environment, judge their personal situation, and perceive possibilities for movement. They register obstacles or hazards.

As we know, the manner of orientation is certainly not the same for all living things. Take, for example, bats, which orient themselves by sound waves, or carrier pigeons, which can find their way home even if they have been transported somewhere in a closed cage.

Visual orientation permits the perception of the most varied characteristics, such as, for example, the size and distance of objects. But states can also be perceived. We can see the hot glow of coal in a fireplace. We can recognize a ripe blueberry by its color. Hence color is not merely a physical characteristic, such as, for example, weight. Instead, color is visual information.

Color differences can be recognized when details in the field of vision lead to differing codes due to the spectral makeup of their color stimuli.

In the visual recognition of objects, the chain of effects between light emission and reception of the color stimulus by the eye always takes basically the same course. Energy rays are sent out in the visible spectrum by a light source. In daylight, the sun of course is that light source. These energy rays fall upon objects and materials. They are partially absorbed, partially remitted (reflected), and partially transmitted (allowed to pass through). This, at any rate, is the case generally speaking. In the extreme case, all of the radiation can be absorbed. We will then get the color sensation black. But it can also be totally remitted or transmitted—which leads to the color sensation white.

Each material has its own specific individual reflection capacity. The energy of the unremitted part of radiation is "retained." In the summer, sand along the beach in Spain becomes so hot at noon due to solar radiation that one cannot step on it barefoot. Here, absorbed radiation has been converted into heat.

From a chemical point of view, all matter differs in its molecular structure. Depending on the molecular structure of the material, a certain part of the incident light is absorbed. The rest is remitted or transmitted and can reach an observer's eye. Hence, this color stimulus is the remnant of illumination light that was not absorbed ("residual light").

We refer to the colorful appearance of matter as "object color" (the term "surface color" is also used for this sensation). By object color we generally mean the individual residual light, because these forwarded light rays are the information transmitters. On the other hand, one could naturally also mean the absorption potential of matter by the term pigment.

Anyone who can understand these interrelationships must realize that object color cannot be something fixed or unalterable, because the spectral composition of the color stimulus always depends on the spectral composition of the existing illumination. Even if material has the ability to remit certain wavelengths, this cannot happen if these wavelengths are not present in the available light.

This clearly shows that light rays are not themselves colorful nor do they carry color. Light rays are merely transmitters of information. Just as a punched tape is not a message, so the color stimulus is not a color. A message can come out of a punched tape only if a corresponding instrument is available to convert the codes

into a message. The color stimulus likewise can become a "color" only if an intact visual system allows the corresponding color perception to result.

Demonstration:
A piece of roofing paper, 20 × 20 cm or larger

We want not only to demonstrate that light has the function of transmitting visual data. We also want to show that light is vital in certain cases. Plants need a portion of light as energy under certain circumstances in order for their biochemical process to take its course—the process that allows them to live.

Put a piece of roofing paper or some other material that does not allow light to pass through on the grass. It is best to conduct this experiment during the relatively dry summer season. After only one or two days you will see that the grass has died.

Anyone who suspects that this is due to the fact that the grass was crushed and that it was therefore unable to take on nitrogen and give off oxygen might build a box that does not allow any light in but through which air can circulate.

Findings: Light energy not only has the task of transmitting information about the physical outside world to living things; it is also a vitally necessary energy source for certain living things.

§ 25 The Light Spectrum
The spectrum is the systematic arrangement of visible energy rays by wavelengths.

The preceding chapters clearly show that "white" light cannot be homogeneous (something made up of the same substance). It does not consist of white light rays, as a layman might think. Instead, light that is perceived as being white is always heterogeneous (composite). The perception of white can come about only if all three cone types in the retina of the eye are simultaneously affected with corresponding intensity.

The spectral composition of white light can be rendered visible and examined by means of its spectrum. To do this we send a ray of light through a refracting medium, for example, a glass prism. For the physically "clean" analysis of the spectrum we must, however, use double refraction. Special instruments used for this purpose are called double monochromators.

Because each wavelength has a different refraction index, the light ray is spread out after it comes out of the refracting medium. This pulling apart of its spectral components, the process of rendering the spectral composition visible in an adjacent pattern, is called "spectrum." Color fig. 13 shows the spectrum of white light.

In this way we get the systematic arrangement in fig. 52. We are logically dealing here with precisely that segment of the wave scale of electromagnetic oscillations that was left blank in fig. 49 as a "window."

| 400nm | 500nm | 600nm | 700nm |

52 Arrangement of visible energy rays in the spectrum

Just as soldiers are lined up according to height in rank and file, we find the visible energy rays as if they had "fallen in" according to the size of their wavelengths in the spectrum.

The radiation of a single wavelength that has been "filtered out" due to double refraction is called "monochromatic." Semantically, this means "single-color" or "individual-color." This term is not very meaningful because, as we know, energy rays are colorless.

In fig. 53 we find numerous measurement points that were obtained by means of the absorption measurement of cone fluids. These three curves, which represent the reception sectors of the three cone types, are also called "spectral tristimulus values."

In this figure we can find the abbreviations of five chromatic basic colors above the vertical lines. From the diagram we see that the most intensive color sensation for the basic colors violet-blue (V),

53 Reception sectors with associated wavelengths

green (G), and orange-red (O) can come about only if, in the sector of the lines entered, such strong radiations are present that the entire perception potential can be mobilized.

We can also tell from the diagram that we should not expect to find the basic colors cyan-blue (C) and yellow (Y) strongly and intensively in the spectrum. This is not possible because the vertical lines show us how the corresponding radiations in each case partially affect two reception sectors. The basic colors C and Y can be perceived with full intensity only if the maximum potential is mobilized in each of the two reception sectors involved. For C this is the case when lines V and G come together. For Y, the radiations that correspond to lines G and O must simultaneously be present with full intensity.

The color sectors that can be seen in the spectrum are called violet-blue, cyan-blue, green, yellow, and orange-red. The careful reader will note that the sixth chromatic basic color, magenta-red, is not represented in the spectrum. Nor should we expect to find it there, because the sensation of magenta-red can result only if the reception areas V and O are activated simultaneously. But because there is no overlap sector between them on the basis of the arrangement here, the perception of magenta-red cannot materialize through the spectrum.

We can clearly see here how problematical it is to work with concepts like "dominant wavelengths." Just as there cannot be a dominant wavelength for M, so there cannot really be such a thing for C or Y if we think the whole thing through precisely. This is because the radiation intensities, for example, of "monochromatic" wavelength C deliver their quanta partly in reception sector V and partly in reception sector G.

Demonstration:
Dark room
Projector
Slide frame with slot
Glass prism [M]

Set up an ordinary slide projector in a darkened room. Prepare a little slide frame of black paper with a narrow perpendicular slit in the middle. The width of this slit should be no more than 0.25–0.5 mm.

Transmit the resultant light ray through a glass prism which, if you are lucky, you can buy from an optician. The light is refracted. The individual wavelengths are deflected from their direction of radiation at a different refraction angle. Thus the spectrum can be intercepted on the wall or on a screen.

First sharply adjust the slit to the distance of the projected image. Then place the prism in the path of the rays, roughly as shown in fig. 54. Move it back and forth by means of rotation until you can see a magnificently colorful spectrum.

Fig. 54 enables us to arrive at an accurate analysis of this process. The reception sectors of the cone types are indicated by brackets. Before the insertion of the prism, the image of the slit struck the same point in the retina in all radiation sectors. But in the spectrum it is shifted and drawn apart for the three reception sectors of the cones: it no longer "fits." We are familiar with unmatching color borders of picture elements in television and multicolor printing. For the same reason, the achromatic white light ray becomes the colorful quality of the spectrum.

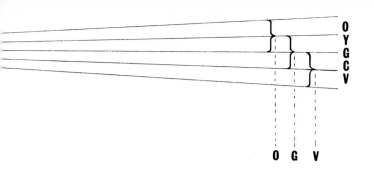

O
Y
G
C
V

O G V

54 Refraction of light ray by prism

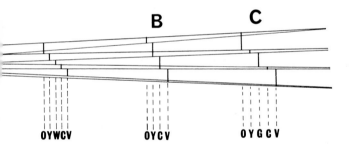

B C

OYWCV OYCV O Y G C V

55 Radiation on one side of prism

If the slit is too wide, the refraction angle will not be enough to separate the individual images sufficiently for the reception sectors of the cone type. In such cases, we see, on the one side, a colored border that runs from orange-red via yellow into white. On the other side, we have the colors cyan-blue and violet-blue between white and black.

It is worthwhile to vary this experiment. While in the arrangement in fig. 54 the prism was directly in front of the lens of the projector, now move it away until the light ray has the width of the outside surface of the prism. Once again move the prism into the path of the rays, as shown in fig. 55. In this arrangement it is interesting to move the picture screen at various intervals behind the prism into the path of the rays.

Fig. 56 clarifies the positions indicated in fig. 55. If the distance to the prism is short, we can only recognize narrow color borders. White is dominant in the middle (fig. 56 A). As the interval increases, the white strip becomes narrower. In a certain position (fig. 56 B) it disappears entirely. The projected image now consists of O, Y, C, and V. Only if we move even further away does the full spectrum become visible (fig. 56 C). We now get a green strip in the middle.

The explanation for this is extremely simple. We need only to visualize how the image components "fit" for the individual reception sectors before, and were therefore seen in the achromatic color white. In fig. 56, however, we recognize how they are increasingly drawn apart as a function of the distance to the prism. At A they still partly overlap. When all three are superimposed, we are left with perception of white. When only two of them meet, we get the perceptions of Y or C. Where only one appears alone, we perceive the colors O, or V.

Position B shows how the parts of the image are moved so far apart that the one for O and the one for V just barely touch each other. Specifically, white has now disappeared but the perception of green can result in position C only if there is a corresponding interval between the parts of the image for O and for V.

Findings: The spectrum has the color sectors violet-blue, cyan-blue, green, yellow, and orange-red. The basic color magenta-red cannot be represented in the spectrum because there is no single wavelength that simultaneously could affect the reception sectors of the cone types V and O.

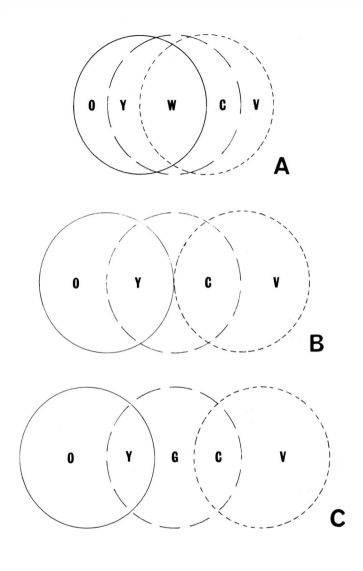

56 Shifting of image on retina due to refraction

§ 26 The Border Spectra

Border spectra result when image separations reach different places in the retina due to refraction.

The term "border spectra" is used for chromatic color fringes that can be seen when one views outlines through a prism. Border spectra also comes about due to refraction. The only difference is that, in this case, the course of the chain reaction is the other way around, "inverted" so to speak.

But let us begin by considering the white stripe in the black field (fig. 57) through a prism. The axis of the prism must run parallel to the stripe. We must look into the prism in the manner shown in fig. 58 because otherwise the sequence of colors in the border spectra will be reversed.

We see the stripe in white with slightly blurred edges if we move very close to it with the prism. But the moment we increase the interval to 30 cm, we perceive, instead of the white stripe, an orange-red one, a green one, and a violet-blue one. Along the upper edge and along the lower edge of the black field we likewise find color fringes now. At the top we get cyan-blue and violet-blue, at the bottom we get orange-red and yellow. Instead of the black and white fig. 57 we now see chromatic color phenomena through the prism. How can this be explained?

We have said that the course of the chain reaction was "inverted" here. The reflection of the white stripe assumed the role of the light ray. This remission falls into the prism and is refracted there. The image of the white stripe that reaches the retina no longer fits. It has been drawn apart by refraction. The image parts for the reception sectors of the three cone types have been shifted. They are reproduced next to each other, as we can see from the beam path in fig. 58.

We pointed out earlier that the border colors change according to the distance between the prism and the image. Fig. 58 clearly shows how we can vary the experiment by altering the distances to a white paper strip (A-D) viewed against a black background (G). Here, the eye (F) and the prism (E) remain in the same position. In other words: observation conditions remaining otherwise unchanged, only the distance between the white paper strip and the prism is changed.

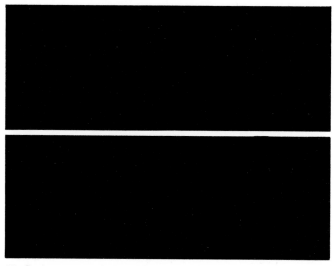

57 Border spectrum of white stripe

In position D we see almost no chromatic colors. The strip is still white and has merely developed somewhat blurred fringes. In position C we are already dealing with the luminous border spectra but we still have a white zone in the middle of the strip. The sequence of the colors (from top to bottom) is now as follows: B, O, Y, W, C, V, B. Only as we move into position B does white disappear entirely. Now the color sequence is B, O, Y, C, V, B. If we increase the distance to position A, we see only B, O, G, V, B as dominant colors.

Now look at fig. 59 through the prism. To our utter astonishment, we see (assuming we maintain the proper distance) three stripes in the colors cyan-blue, magenta-red, and yellow instead of the black stripe. This indeed seems to be quite incredible at first sight. Figs. 60 and 61 also present the phenomenon of border spectra to us in an impressive manner.

The observation of such border spectra is just as fascinating as it is easy to perform. In addition, it demonstrates how the visual system works. No special circumstances are necessary because the

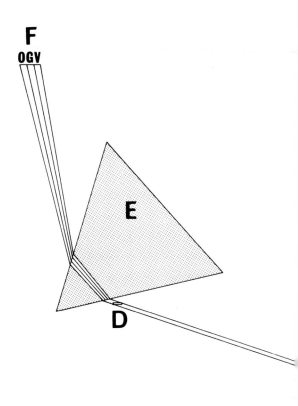

observations can be made in a normally lighted room by several people at the same time. This, of course, is particularly interesting for school classes. The images to be examined through the prism can be made in a correspondingly large format and attached to the wall so that all observers can see them simultaneously. Naturally, there must be a small prism available for each person. A larger number of such prisms can be purchased inexpensively [N]. Even if funds are short, every school should be able to procure at least one "classroom set" of prisms. The necessary black and white images can easily be made during art class. As we shall see, all important interrelationships of color theory can be meaningfully derived from the border spectra.

Demonstration:
Brightly lit room, daylight is best
Black and white images (as in figs. 62 and 64)
Prisms

The aim is to explain the origin of border spectra in the most suitable instructional manner.

Using the same observation arrangement as before, look at fig. 62. Select the prism interval in such a manner that the colors of the border spectra are presented as in color fig. 14. To do this, you must alter the prism interval so that, in step B, you obtain exactly the same situation in which the white stripe just disappears. In other words, neither white nor green should be visible in the middle. For this step B (going from top to bottom) we get the sequence B, O, Y, C, V, B.

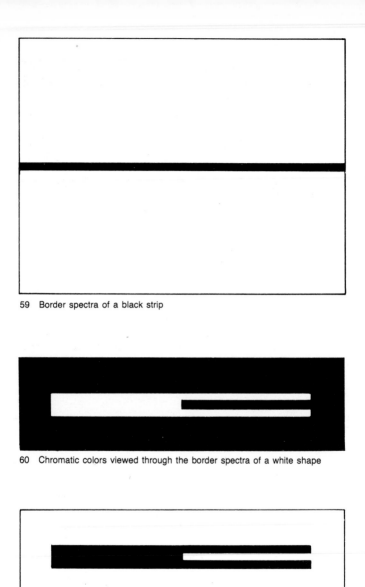

59 Border spectra of a black strip

60 Chromatic colors viewed through the border spectra of a white shape

61 Chromatic colors viewed through the border spectra of a black shape

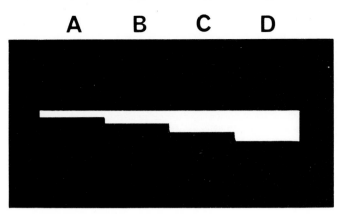

62 Border spectra with white areas growing larger

Now look at step A. There we see only the colors O, G, and V as dominant stripes. At both step C and step D, on the other hand, a white zone remains in the middle. There we have the color sequence B, O, Y, W, C, V, B.

The explanation for why we get these color phenomena can be found in fig. 63. Step A is so low that the optical shift due to refraction is sufficient to place the image components for the three cone reception sectors next to each other. Step B, however, is twice as high. The refraction is now no longer sufficient to shift the image components in such a manner that they will occur completely separately. Here we have reached exactly the same position in which the lower edge of the image component for reception sector O occurs together with the upper one of the image component for sector V. They just touch each other. The image component for sector G is superimposed on both of them.

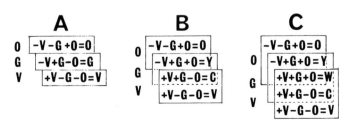

63 Explanation of border spectra in fig. 62

On the left, on the outside, the individual image components in each step are designated by the abbreviations O, G, and V. To make the situation clearer, the surfaces of the image components have been shifted slightly to the right. A sort of formula is entered in each of the resulting bands. It tells us something as to why the particular color perception comes about. On the right, next to the equal sign, is indicated what color is to be seen.

In step B, there cannot be any white color perception because there is no place on the retina where the color stimuli for all three reception sectors are superimposed. Here, a maximum of two are stimulated, which leads to the perceptions of Y and C. Where only one reception sector can be activated, we get O or V.

Because the areas of steps C and D are correspondingly higher, a white zone results in the middle in each case. This is because refraction is no longer great enough to move the image components sufficiently far apart. The perception of white therefore occurs where all three image components are superimposed upon each other because that is where color stimuli are being given off for all three reception sectors.

Now look at fig. 64 under the same observation conditions. With the prism, the chromatic arrangement in color fig. 15 results.

The black shape in fig. 64 is the negative counterpart of the white shape in fig. 62. Once again equalize the prism interval in such a manner that you see only chromatic colors at step B. In other words, a black stripe should not develop in the middle. The color sequence here is W, C, V, O, Y, W.

The explanation for the origin of these colors can be found in fig. 65. Here again the image components are shifted slightly to the right to make the

64 Border spectra with black areas growing larger

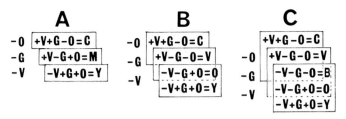

65 Explanation of border spectra in fig. 64

situation clearer. Here, likewise, the designations for the image components are placed on the outside, on the left, as abbreviations. But there is a minus sign in front in each case because the black areas of the individual steps signify the absence of color stimuli for all three reception sectors. If we look at fig. 64 directly, in other words, not through a prism, it will be reproduced on the retina precisely. The "recesses" in the color stimuli are superimposed sharply along their edges and together bring about the black appearance of the shape. These recesses are basically negative image components. This is why a minus sign is placed in each case in front of the abbreviation for the particular reception sector.

These "holes" are projected to other places on the retina due to refraction. The negative image components no longer fit exactly on top of each other; we obtain border spectra.

In step B, the negative image components of O and V touch each other. They are superimposed by the negative image component G. We thus get the color sequence W, C, V, O, Y, W (see fig. 65).

Step A again is so low that refraction is barely enough to place the negative image components next to each other. Where O is masked, we get the color perception C; where G is absent, we get M; and where V is not present, we see Y.

In steps C and D, black zones result in the middle because refraction is not sufficient to move the negative image components sufficiently far apart. Where they are superimposed, there is bound to be a color perception of black. This is because no color stimulus is present for any of the three reception sectors at these points. We thus get the color sequence W, C, V, B, O, Y, W.

In fig. 62, the border spectra (color fig. 14) resulted from the fact that the image components were shifted by refraction and were reproduced on various places on the retina. The color stimulus content of the white steps could become selectively visible because no foreign influence could take effect due to the black surrounding field in the course of refraction.

On the other hand, in fig. 64 we are really not dealing with the black shape of the steps at all but rather with the white surrounding fields. Now the chromatic colors of the border spectra result from the "extinction" of the particular reception sectors. As a result of refraction, the color stimuli coming from the white surrounding field are drawn over the "holes." If the image components of the surrounding field fit exactly on top of each other, this will look white to us. The chromatic colors become visible in that they are shifted in differing ways.

It was pointed out earlier that these descriptions are correct only if we select the observation arrangement in fig. 58. If we look through the upper edge of the prism, everything will turn around in sequence. It is astonishing to note that, in the case of a certain direction of observation, the magnificent border spectra in figs. 62 and 64 can be seen in the prism with the sides reversed. For the sake of completeness it must be pointed out that such border spectra naturally can occur only in the direction of refraction. Only where the boundary lines are shifted with respect to each other can other colors become visible. To the extent that the contours remain on top of each other in a vertical direction in spite of refraction, there will be no color effects because there is no difference in register here between the image components.

Findings: Border spectra are marginal colors that result from refraction. As the remission ray is refracted, the image components for the individual cone reception sectors are shifted and thus are not reproduced in register. In this way, spectra result on the retina of the eye.

Historical Note: The famous experiment by Isaac Newton (1643-1727), to break a ray of sunlight down into its "colored spectral components" by means of prism refraction, led to a color theory in physics that is still the scientific foundation for colorimetry (radiation measurement). Throughout his life, Johann Wolfgang von Goethe (1749-1832) fought against Newton's theory with strong commitment and forceful debate. Goethe particularly devoted himself to the phenomena of border spectra, for which Newton's theory did not seem to offer him any satisfactory explanation. In the light of our present-day knowledge it seems almost incomprehensivle how this historical controversy could have arisen in the first place. It is quite obvious that both the light spectrum and the border spectra must basically be explained by the same law.

Goethe's unreasonable attitude is all the more astonishing since his contemporary and discussion partner Arthur Schopenhauer (1788-1860), in an essay entitled "Color Theory," described these interrelationships in a basically correct fashion as early as 1815. Of course, one must keep in mind that Goethe at that time was 66 years old and at the height of his frame. Schopenhauer, on the other hand, was just 27 years old and moreover held a view differenct from that of the great master. It is therefore no wonder that his book was not printed in a second edition until 40 years later.

Nevertheless, Goethe, who could not believe in Newton's rays, was essentially correct. Light rays indeed are not color. They are a certain form of energy and in nature they act as a "vehicle" for transporting information. "Color," as we know today, is only color sensation.

§ 27 The Color Stimulus Function

For every color stimulus, the color stimulus function is the physical "wanted poster."

Every color stimulus is made up of visible energy rays that we have come to know as the wavelengths of the spectrum and which are customarily referred to as "light rays."

The spectral composition of a color stimulus can always be traced back to two parameters: (1) the wavelengths present and (2) the intensity of the particular radiation.

Since from a physical point of view we have only these two parameters, it is a good idea to illustrate the spectral content of a color stimulus as a function in a coordinate system. As we know, in this type of function we are dealing with a horizontal arrangement (abscissa) and a vertical arrangement (ordinate). On the abscissa, which is designated as x in fig. 66, we plot the wavelengths from left to right, starting with 400 nm. The ordinate gives us the relative intensity of the radiation. It is designated as y.

What sounds rather complicated here is basically nothing but the graphic illustration of interrelationships, the process of rendering visible statistical facts.

Let us take a very simple example: a mother buys 20 applies for her child, which the latter consumes in 10 days. The child thus ate an average of two apples per day. In reality, the situation may have been different; fig. 67 shows that the child ate only one apple on the first day and increased the quantity on the second and third days to two apples each. On the fourth day, the child consumed three and on the fifth day he consumed five apples. Obviously, that led to stomach trouble because the child fasted on the sixth day. On the seventh day he once again ate an apple and from the eighth to the tenth days he ate two apples per day. The statistics might lead us to assume that the child learned his lesson and the quantity of two apples per day seemed most suitable to him.

The little "x" marks in fig. 67 are the daily "measurement points." They express the relationship between the time expired and the pertinent consumption (quantity). The curve in fig. 68 provides exactly the same information. The measurement points are merely connected with a curved line here.

The illustration of such conditions in the form of curves is something we are all familiar with from everyday life. Let us just think of the fever curve of a patient, in which the relationship between the time and the body temperature is recorded and which tells the doctor what the situation is at a glance. Or let us think of

66 A coordinate system shows a function

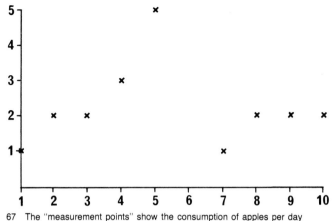

67 The "measurement points" show the consumption of apples per day

the number of automobiles newly licensed year after year, a number that fluctuates tremendously as a function of recession or boom.

Demonstration:
Blackboard
Chalk

The color stimulus function can be explained by first drawing a horizontal arrow on the blackboard, pointing to the right. At its left end, start drawing little tick marks as in fig. 69 and write the nanometer data in the proper places. Explain that this is the systematic arrangement of all visible energy rays. Now erase the remaining end of the arrow at 700 nm.

Now draw a perpendicular arrow pointing upward above the point "400 nm" and explain that it gives us the relative intensities for the wavelengths. Enter the values from fig. 69 and then erase the remaining arrow head.

Such color stimulus functions can be found indicated primarily for the sector between 400 nm and 700 nm, and occasionally for the sector between 380 nm and 720 nm as well. The radiations outside these wavelengths are practically meaningless because the visual system no longer has any noteworthy sensitivities there (see fig. 50).

In fig. 70 we find the curve for a color stimulus functions, which we now enter in the prepared coordinate scheme. Each wavelength here is matched up with a relative intensity. We are dealing with the physical analysis of a color stimulus, its physical "wanted poster," so to speak.

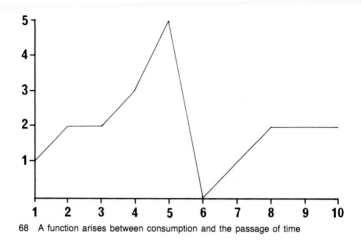

68 A function arises between consumption and the passage of time

In practice, of course, a measurement of intensity is not made for each individual wavelength. Instead, we measure in steps of 10 or 20 nm or more. Thus we get a corresponding number of measurement points, which we connect to form a curve. Obviously, this kind of color stimulus function is more accurate the more measurement points are determined. There are spectrophotometers that draw such curves automatically with the utmost accuracy ([S] and [T]).

The existing intensities are plotted in gray in the diagram in fig. 70. Let us assume that we are dealing here with the reflection of an opaque material, in other words, an object color. Minor intensities are present in both the short-wave and the long-wave range. As fig. 71 shows schematically, they lead to a whitening—a portion of white in the perception. The largest common intensity value is plotted in gray in the diagram.

On the other hand, fig. 72 clearly shows that the perception potential is not fully activated in any wavelength sector. There is a certain absorption in the heavily reflecting spectral sectors as well, as indicated by the gray band in this diagram. There is a blackening by virtue of this unused potential which in turn creates the perception of a portion of black.

It follows from these realizations that, in the reflection curve in fig. 70, we are dealing with an impure green color.

Naturally, a color stimulus function is an objective, absolutely exact scientific definition—although it is a physical one. But let us not forget the interrelationships illustrated in fig. 73 here. The color stimulus, after all, is only the "messenger" that "carries" certain information which is delivered to the three cone types, whose reception sectors are indicated by broken lines. Energy quanta are given off to the cone types in different quantities.

69 Function between wavelengths and relative intensity

129

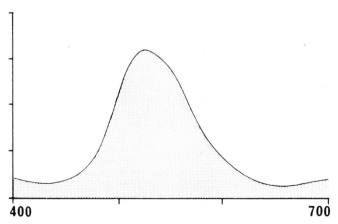

70 Color stimulus function of a green object color

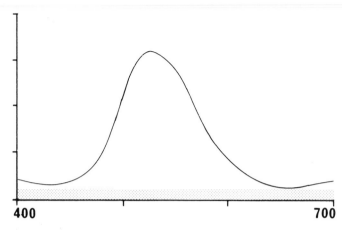

71 Share of whitening in color stimulus

The visual system, however, makes up the code that leads to the color sensation as a function of the adaptation situation, influenced by the surrounding colors (simultaneous contrast).

We must briefly explain here why we mentioned "relative intensity." The illustration of the color stimulus function basically involves the quantitative relationships among wavelength intensities. The "spectral mixing ratio" so to speak, is given here. If we are dealing with the illustration of an emission—in other words, direct light radiation—we assign a value of 100% to the highest existing intensity. But if we are dealing with a reflection, we put the value of 100% for the intensity radiated for each wavelength and indicate the percentage figure for the particular reflection by the curve itself.

Findings: A color stimulus function is the graphic illustration of the visible radiation intensities represented in the color stimulus. In place of the concept of "color stimulus function" we also find the concepts "reflection curve" or "emission curve" or "spectral curve." We are always dealing with the "physical profile" of a color stimulus here.

To be sure, color stimulus functions are objectively measurable physical facts. But since the visual system causes correction processes to take place according to its own laws, there are no fixed correlations between color stimuli and color perceptions.

72 Share of blackening

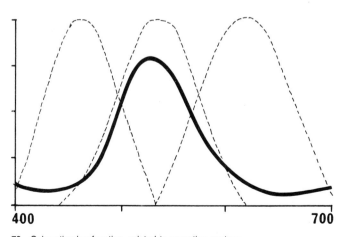

73 Color stimulus function, related to reception sectors

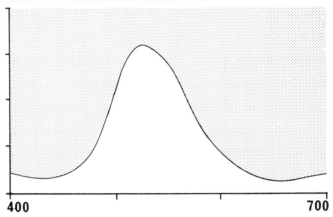

74 Sector absorbed by green material

§ 28 Complementary Colors and Compensatory Colors

Complementary color stimuli supplement each other to form white and compensatory color stimuli merely neutralize each other to form achromatic values.

In fig. 70, we learned about the color stimulus function of an impure green color agent. The gray area under the curve was to be understood as the "listing" of wavelengths represented in the color stimulus with an indication of the particular intensities.

We know that such a reflection curve comes about because the material has absorbed the unreflected intensities of the white illumination light. We have also called such reflection "residual light." Hence the general illumination light was split up into two parts; one part was absorbed, the other was reflected. It is logical that these two parts, if we were to put them together again, would become what they were before, that is, white light.

The curve in fig. 70 shows us the reflected portion of white light. We find its counterpart in fig. 74. In the case of white light, we are dealing with an "equi-energy spectrum," as shown in fig. 75; the gray area in fig. 74 represents the absorbed parts of white light.

We find the same spectral content that was illustrated in fig. 74 as absorption as color stimulus function in fig. 76. This means that the two color stimuli illustrated in figs. 70 and 76 together—that is, if

75 The equi-energy spectrum

they simultaneously strike the same point on the retina—must lead to the color perception white because they, after all, are united in the equi-energy spectrum in fig. 75. Color stimulus functions that supplement each other to form an equi-energy spectrum in this fashion are called "complementary."

The color stimulus, however, is not "color," but only the impetus that causes the visual system to produce a color sensation. This is

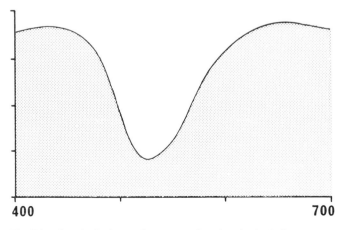

76 This color stimulus is complementary to the color stimulus in fig. 70

why it is quite clear that not only those color stimuli that supplement each other to form an equi-energy spectrum are complementary, but also all those that lead to the same color perception, that is to say, all those that look alike. After all, the important thing is not the color stimulus function, but the code formations, and color stimuli reveal the same appearance if they lead to the same code formation.

We must therefore conclude that all color stimuli are complementary if they supplement an existing code so that the color perception white results.

But we can tell from fig. 74 that we do not need all of the intensities illustrated in gray in order to turn the given color stimulus, which led to a green perception, into an achromatic color perception. For example, the sector above the curve that remained white in fig. 72 suffices. It could, however, also be a sector such as the one delineated by the broken line in the same diagram.

Such color stimuli, which merely reshape an existing code so that an achromatic color perception (in other words, a gray shade) develops, are called compensatory. For instructional purposes, it would probably be meaningful to speak of "minimal" and "maximal" complementary colors.

Here again it is not decisive whether the compensatory color stimulus for an existing color stimulus function brings about the spectral (physical) equalization. Instead, every color stimulus with the same appearance also leads to the same results. We know, after all, that the same appearance comes about through identical code values. The important thing here is the change in the code, its "transformation," not the spectral composition of the color stimulus. In other words: the color stimulus is only the cause and the color sensation is the effect. Compensation naturally must always relate to the effect.

Demonstration:
Two projectors [O]
Two slide frames
Black paper
Interference filter [P]
Dark room

In the following optical experiments we want not only to demonstrate what complementary colors are, but also to clearly demonstrate all of the preceding theory.

In a dark room, aim the beam of light from two projectors at a white wall or a screen. Into two slide frames insert black paper out of each of which two circular holes have been cut. Then place the frames into the picture plane of the projector.

There must be some room left between the picture plane of the projector and the lens in order to attach a provisional retaining device for interference filters, which are often so thick that they cannot readily be inserted in place of a slide. The retaining device can easily be made of wire or thin sheet metal and can be suspended so that it will not interfere with the path of the rays.

Use interference filters with a band width of about 20 nm. (Interference filters are special filters that allow only this narrow spectral range to pass through.) The following values relate to the average wavelength of the passage sector. Start with the filter pair Blue 469 nm and Yellow 587 nm.

First allow the circular surfaces to remain next to each other on the projection screen. Then alter the direction of projection of one projector so that they partially overlap. Finally, allow the circles to coincide precisely with each other.

First we see a blue and a yellow hue. Where these two lights are blended, we get the color perception white, specifically, a relatively "warm" (reddish-yellow) white. If we flip back to fig. 53, we realize why this is so: each of the two narrow-band spectral segments stimulates two types of cones, with differing intensity. Cone types V and G react to the 469-nm filter; G and O react to the 587-nm filter. The largest common value in the resultant three-part code corresponds to the portion of white. Obviously, however, the green receptor is stimulated somewhat more and the orange-red receptor is stimulated even more, so that the white light acquires the previously mentioned tint. The two hues of the 469-nm and 587-nm filters are thus not complementary colors.

Now insert the filters with the violet-blue hue 428 nm and with the greenish-yellow one, 569 nm, into the projectors. By reducing the intensity of the yellow-green by means of thin gray filters (pieces of film with a density of 0.1), we now manage to produce a neutral white light here. Obviously, the 428-nm filter extensively affects only the V cone type, while G and O are stimulated rather evenly by 569 nm. This results in a code that is balanced in all three reception sectors and leads to the color perception white.

Now proceed in the same manner with the filter pair turquoise 492 nm and orange-red 627 nm. First note that orange-red has an intensity that is much too strong. We need three or four of the above-mentioned gray filters in order to coordinate the intensities of the two hues so that the color perception white results. Filter 492 nm corresponds to reception sectors V and G; while filter 627 nm is exclusively in the reception sector O.

The last two filter pairs are complementary colors, or more precisely, hues that produce white when their radiation intensities are coordinated with each other.

Findings: Color stimuli that strike the same point in the retina are complementary if together they lead to the color sensation white. They are compensatory if their union leads to an achromatic color perception. All hues that have a correspondingly identical appearance are either complementary or compensatory. The important thing here is not the spectral composition of the color stimulus, but rather the code values occurring in the visual system.

It follows from this that color stimuli that lead to complementary perceptions in the form of reflections under certain conditions of illumination and observation are no longer complementary under certain circumstances in different conditions of illumination and observation.

§ 29 "White" Light

If a light is called "white", that tells nothing about the quality of its spectral composition.

We are accustomed to considering a white sheet of paper as always being white, regardless of the illumination. In the morning, at noon, and at night, in daylight and artificial light, a white sheet of paper looks white to us.

On the other hand, it is generally known that one cannot rely on the appearance of material, on its "color," in artificial light. It is a widespread view that daylight shows the colors of things "correctly." Of course, that view is wrong, because "daylight" does not exist at all. Depending on the season, the position of the sun, and the weather, the spectral composition of daylight changes enormously under certain circumstances. When the sun sets on a beautiful summer day in the mountains, the last light is reflected on the snow up on the slopes. This is called "Alpine glow," which is a kind of daylight that overwhelmingly consists of long-wave radiations and therefore leads to an orange-red illumination. Every amateur photographer has had the disappointing experience that it is not at all worthwhile to take pictures at noon in the middle of the

summer; the photos acquire a blue-violet tint. This is due to the fact that this type of daylight is overwhelmingly made up of short-wave radiations. Because color film cannot adapt like a human being's visual system, it records what is present.

For the industrial, crafts, and artistic utilization of color it is of decisive importance to be able to communicate about hues and the appearance of material and color media without any misunderstandings. But this is basically possible only by referring to the light used. The particular materials can look different in a different light, as we already know.

In the past it was customary to designate the type of light by "degrees Kelvin" or simply "Kelvin." We are referring to the emission of the so-called "Planck radiator," which emits light of varying spectral composition as a function of its heating temperature. (This is a hollow body with an opening. By causing it to glow, it radiates light rays with varying wavelength intensities, depending upon the temperature.) The term "Kelvin," however, does not refer to the spectral makeup of the particular emission of the Planck radiator, but only to the appearance of the light color (color temperature). It is clear that this manner of designation of light qualities cannot in any way meet the demands of science and technology.

Anybody who carefully thinks about these interrelationships will understand that it is not only desirable but absolutely necessary to arrive at a standard light. But what should be the nature of this standard light and how should it be defined scientifically?

It would be logical to conduct statistical studies on the spectral composition of daylight throughout an entire year. One would have to examine the particular composition at regular intervals of, for example, one or two hours. At the end, one would have to calculate the statistical mean. In this way one could determine the "ideal standard light." The equi-energy spectrum in fig. 75, which otherwise would be very clear, unfortunately is not suitable here because short-wave radiations predominate considerably in daylight in statistical terms.

The realization of the need for standardizing illumination and observation conditions has already led to various standard plans [Q] (unfortunately without statistically precise investigations). This nevertheless should basically be welcomed without reservations in order to stabilize the conditions of evaluation.

These new standard plans consider the two types of light D_{65} and D_{50}. Unfortunately, these two different types of light—not just one of them, which would be preferable—are now under discussion. In the term "D_{65}" the "D" means "daylight" and 65 stands for the appearance of light color (color temperature) corresponding to 6,5000 Kelvin. In contrast to Kelvin, however, D_{65} indicates a precisely defined, continuous spectral composition of this white light. Light type D_{50} corresponds to the appearance of 5,000 Kelvin and thus roughly to an energy-equal spectrum. This type of light should, if possible only through conversion, be used exclusively for looking at color slides, because the color film material used today is geared toward this type of "warmer" light. It would be much more meaningful if film manufacturers in the future would coordinate the color of their film layers with D_{65} in accordance with theoretical findings. Then we could get along with this one standard type of light for all sample coordinating processes (examination and coordination of colored materials for identical appearance). This, of course, is countered by the fact that the lamps in projectors would also have to be changed accordingly. Unfortunately, technological problems seem to make that impossible today.

Demonstration:
Three projectors [O]
Inteference filters [E]
Dark room

In the demonstration of complementary colors (Section 28) we clearly showed that light can look white and still be completely unsuited for the illumination of colored objects.

We now want to expand this demonstration by adding a third projector in the manner described. Insert the interference filters 448 nm, 518 nm, and 617 nm into the provisional retaining device. This is the classical experimental arrangement for the presentation of the "additive mixture of color stimuli" which we will come to later. It is worthwhile to start with an arrangement like the one in color fig. 22. We can see that we can allow the perception of all eight basic colors to materialize by means of these three narrow-band radiation intensities. In other words: the perception mechanisms of the visual system would be "fully involved" in these three color stimulus types. We could build up with great success the technology of color television on these three color stimuli, which of course would have to be variable in intensity, because we could stimulate the visual system into producing all imaginable color sensations.

Although these blended color stimuli (in the meantime make the circles of light coincide precisely) produce a white light, they are completely unsuitable as illumination light. If we examine color fig. 12 in this light, the colors orange-red and green are exaggerated; violet-blue does not reveal this exaggeration, which is probably due to the fact that this color, in printing, comes out very "dirty" anyway and that short-wave radiation in the projector light is weak. It is striking to note how much the intensity of the colors yellow, magenta-red, and cyan-blue decreases in this light.

This phenomenon should not surprise us; indeed, we should expect it because, when viewed in normal light, every hue of the hexagon surface has a reflection curve similar to the curve shown in fig. 70. All reflection curves cover relatively broad spectral sectors.

The remission capability of the individual hues, however, cannot be exhausted, because our light, after all, consists only of three narrow wavelength sectors. The reflection possibilities of the hues therefore can be brought to bear partially (and in a very different fashion). For example, in the colors orange-red and green, the existing radiation in each case is at the maximum of the particular reception sector. Here, of course, we get particularly intense color perceptions. On the other hand, the spectral intensities in our light do not fit in with the special reflection possibilities of the yellow, magenta-red, and cyan-blue points. These colors therefore look relatively pale and weak. They are not in a position to fully manifest their individual appearance because the necessary radiation intensities do not exist in the available light.

You should vary this experiment by conducting it with colored papers (for example, [G]) or applications of paint involving the six chromatic basic colors, which should be as pure and luminous as possible. Then these color arrangments should be examined under a white light that consists of only two narrow-band complementary sectors (as described in the preceding chapter) and finally, next to it, one should view the whole thing in "correct" white light. The phenomena can always be explained by the way the visual system works (see fig. 53).

Findings: The term "white" light does not provide us with adequate information. Because the appearance of object colors depends on the spectral composition of light, a certain type of light should be established in order to be able to communicate about colors in a precise way.

§ 30 Metameric and Nonmetameric Colors

Colors that look identical only in one kind of light are referred to as "metameric." Colors that look alike in all kinds of light are called "nonmetameric."

In the field of crafts, and in the artistic and industrial use of color, we encounter the problem of precise color reproduction. It is absolutely necessary in various areas of application to work with nonmetameric colors. In other areas of application this is not necessary, or it is not possible in the first place.

The auto repair business is an obvious example. If a door that has been damaged in an accident is spray painted, one must work with nonmetameric paints. Anyone can easily visualize how impossible it would be if the door were to reveal the same color as the rest of the car body only in a certain type of light while in all others types of light it revealed a different color. This example shows that, in the case of auto repainting, one must use nonmetameric paints so that these enamels will lead to the same color stimulus functions.

If, for example, different materials in the same reference light type have the reflection curve shown in fig. 70, they will look identical not only in this type of light but in all others types of light. They are nonmetameric because they have the same absorption capacity.

In most cases, however, we are dealing with metameric colors during the remixing of hues and during the matching process. Metameric colors, however, exist for example in all reproduction processes, regardless of whether they involve color photography, multicolor printing, or color television. Metameric colors also exist whenever colors are remixed according to samples in artistic or crafts use. A house painter who mixes his emulsion paint according to a paper sample will achieve agreement only at the moment of mixing. If he did his mixing in the morning and the customer looks at the result in the afternoon, there is liable to be trouble because there will be definite color differences between the sample the actual color.

In textile dyeing, we find metameric and nonmetameric colors. For example, if a certain display item is produced in large quantities, one must of course work with nonmetameric dyes. Visual remixing of samples, however, can only lead to metameric colors.

Metameric colors, obviously, look identical only in the type of light in which they were matched. In this connection we once again clearly realize how important the determination of one (and, if possible, *only* one) standard light type is.

Let us take multicolor printing as an example for metameric color reproduction in a technical process. Optimum identity between the original sample and the lithograph is established under light type D_{65} in a reproduction plant. But the salesman shows the customer the reproduction results in daylight, perhaps during rainy weather. It may also have already gotten dark and observation takes place by the light of an electric bulb. Color identity, which existed in the plant, now no longer exists under certain circumstances. Indeed, there might even be definite color differences.

In a reproduction process, there cannot fundamentally be a so-called "facsimile reproduction of the original" because only metameric colors are possible. Only in a defined (or agreed upon) reference light can agreement be established. We realize how senseless it would be if a museum curator were to insist that the paintings in his gallery be reproduced in the catalog as "facsimiles of the originals." A reproduction of a painting can only be a "snapshot." Only one out of an infinite number of illumination situations can be recorded in a reproduction—unless such an object is illuminated exclusively with artificial light and both the illumination and the observation conditions are fixed in this manner. It would be correct and logical in this case if these determinations were to be made by the artists themselves.

Demonstration:
Drawing paper or cardboard
Oil paints

Choose several colored material samples: fabric remnants or stones (including bricks), pieces of wood, parts of plastic substances, foliage, or blossom petals.

In daylight, try to remix the hues as exactly as possible. Use artist's oil paints because they do not change their appearance in drying, the way tempera paints do.

As soon as you have achieved the desired agreement between the samples and the mixing results, darken the room. Now look at the samples and their remixing results in electric light. Under certain circumstances you will be astonished at the color differences that now appear.

Findings: Nonmetameric colors have the same color stimulus functions; they look identical in any type of light. Metameric colors, on the other hand, have varying color stimulus functions; their color identity relates only to a single type of light. In reproduction processes such as color photography, multicolor printing, or color television, we are always dealing with metameric colors.

§ 31 Colorimetry Is the Measurement of Radiation

The special area of physics concerned with the measurement of visible energy rays and with the calculation of pertinent trichromatic values is called colorimetry.

The difficulties encountered in colorimetry reside in the fact that "colors" are only sensory perceptions that cannot be measured.

The approach to colorimetry starts with the way in which the human eye works. If it is true that there are three types of cones in the retina, then it must be possible, with three suitable spectral lights, to cause the human visual system to produce all the different sensations. Each of these three colored lights must be capable of being varied from 0% to 100%. In this kind of procedure it must be possible to "readjust" the appearance of a color sample through corresponding intensities of these three color lights. By this we mean that an observer with normal vision will establish the identity of appearance for both—that is to say, for the sample and for the subsequent remixing result.

These three color lights, which should be coordinated with the reception sectors of the three cone types, are called "reference stimuli." After comprehensive and careful experiments involving many subjects, physicists have determined the following wavelengths for them: violet-blue 435.8 nm, green 546.1 nm, and orange-red 700.0 nm. These "primary values" were established in 1931 by the International Lighting Commission, the CIE (Commission Internationale D'Eclairage), in the so-called CIE system (Standard Colorimetric System). This system has remained the foundation of colorimetry until today, although it has experienced numerous changes, amendments, and transformations.

If, in the manner described, we establish identity of appearance with the color of a sample, the intensity values of the individual primary colors become "measurement coefficients." To pursue this method consistently, one would obviously always have to depend on the judgment of an observer with respect to identity, which would be impractical.

This is why today people prefer to use "objective" spectral methods in colorimetry. Automatically operated measuring instruments record the curves of color stimuli functions. These instruments are called "registering spectral photometers" [S]. The measurement continually moves through the visible range of the spectrum, which is produced by prisms or grids. The degrees of reflection or transmission are continually recorded. Another version of this instrument works with narrow-band interference filters [T].

Of course, these measurement values have nothing at all in common with "color;" they are intensities of colorless energy rays. A connection with "use in colorimetry" comes about only if measurement coefficients are computed for the three reference stimuli. Results of these computations come in the form of the "tristimulus values" (chromaticity coordinates) X, Y, and Z.

Now the situation begins to become complicated, because these tristimulus values must be related to the particular type of light in order, for example, to arrive at the "chromaticity coordinates for standard light type D_{65}." The necessary calculations are lengthy and difficult; nor is this changed by the fact that inexpensive pocket and desk calculators are available today. Where this kind of computation work is regularly required, people therefore prefer to have the job done by computers.

Of course everything could be much simpler if we had three different types of photo cells available whose sensitivities agreed exactly with those of the reception sectors of the three cone types. One could measure the color stimulus to be analyzed in succession with each of these three photoelectric cells and could thus directly obtain the desired chromaticity coordinates X, Y and Z. However, such methods, called "three-sector methods," are unfortunately quite inaccurate. This is due on the one hand to technical problems because, of course, it is impossible to make photoelectric cells in such a manner that they have exactly the same sensitivities as the three cone types. One also needs a standard light type with absolute

Text continues on page 161.

List of Color Figures

1

2 A

2 B

2 C

2 D

3

4

5

6

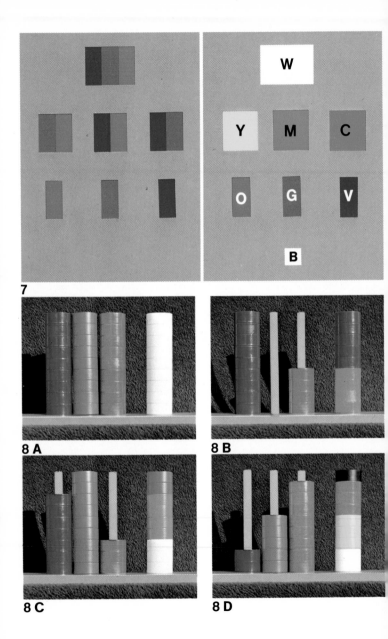

7

8 A

8 B

8 C

8 D

9 A

9 B

9 C

9 D

9 E

9 F

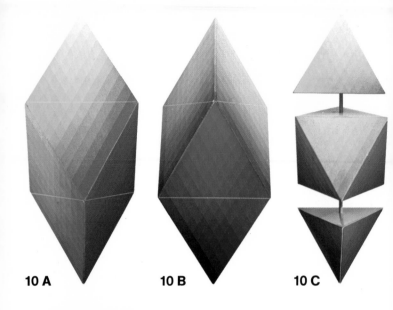

10 A 10 B 10 C

11 A

11 B

12

13

14

15

16

17

18

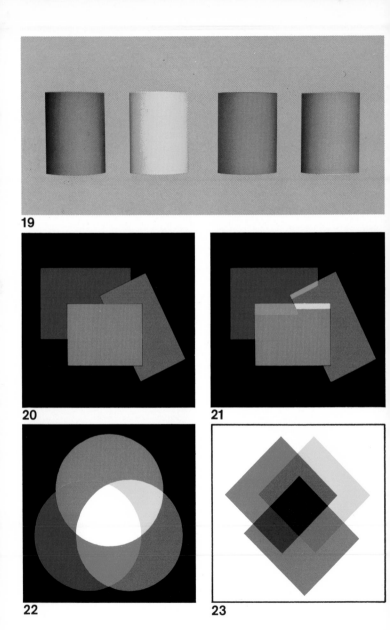

19

20

21

22

23

24

25

26

27

28 A

28 B

28 C

29

30

31 A

31 B

32 A

32 B

33 A

33 B

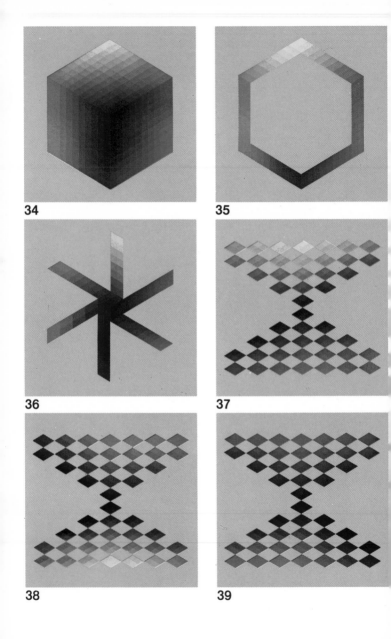

34

35

36

37

38

39

40

41

42

43

44

45

46

47

stability. On the other hand, we do not have an exact knowledge of the reception sectors of the cone types.

The purpose of colorimetry should be practical utility: to determine identity or differences of appearance in the fastest and most reliable manner, or to be able to perform advanced formula computations for mixing. But this is still highly problematical when working with samples or wherever metameric colors are present. It appears that the "measurement instrument" represented by the human eye obviously works according to laws that have not yet been comprehensively identified and that the eye functions much more precisely than colorimetry in establishing visual differences. In practice, therefore, the last corrections in sample matching, whether we are dealing with textile dyeing, the production of enamel paints, or some other area of industry, are performed for the most part by the colorist himself. The reference stimuli determined in the CIE system obviously do not adequately agree with the principle according to which the visual system functions.

Objectively defining color intervals or color differences is another matter. But because no sensorially identical interval situation can exist in the CIE system and all of its amended versions, this is also problematical. Identical differences in the measurement coefficients can indicate different sensory intervals.

If the applied colorimetric system does not agree congruently with the way the human visual system functions, it is only too easily understandable that we will always encounter the greatest difficulties where we need the most accurate possible reproduction of metameric colors. This is probably why colorimetry has thus far been able to attain almost no large significance in the most demanding reproduction systems, such as multicolor printing or color photography.

On the other hand, of course, spectral photometry and colorimetry do have their important fields of assignment and employment. This applies especially, for example, to the remixing of nonmetameric colors. This is because the identity of color stimulus functions can be as precisely established as the existing deviations.

It is difficult to see how colorimetry—on the foundation it has today—could attain any significance for esthetic and artistic application of color in art and design. It is also difficult to conceive that it could be instructionally suitable for furthering the aim of establishing color theory as a normal part of general education.

Demonstration:

Magnetic or adhesive board

Adhesive colored paper, as in color figs. 16-18

The aim of this demonstration is to prove how an objectively identical color stimulus, under identical illumination and observation conditions (in other words, after achromatic and chromatic adaptation and at constant light) can lead to two very different color perceptions.

Make a strip of colored paper as in color fig. 16. First attach it alone to the magnetic board. (If you cannot find suitable paper, apply the corresponding color as required.) It is now clear that the same color stimulus strikes the eye from every point on the paper. This is why we see the strip in a uniform coloration.

Now arrange a cyan-blue colored paper on the left and a reddish-yellow one on the right, in the largest possible surface areas, so that the stripe partially runs over them (color fig. 17). The eye still allows us to recognize the stripe as uniformly isochromatic.

But if you allow the dark blue and yellow stripes in color fig. 18 to cover the horizontal stripe perpendicularly, you see two entirely different hues; we have already encountered this phenomenon as "simultaneous contrast."

Findings: Surrounding colors can cause the visual system in the case of identical color stimuli, to produce different perceptions. Hence identical colorimetric measurement coefficients can be matched up with hues that look different. Therefore it is also logically possible for different measurement coefficients to refer to hues that look alike. In general, in other words, colorimetry does not relate to the appearance of hues. Obviously, the competence of colorimetry (at least presently) lies exclusively in the realm of physics—specifically, in the determination of the identity or difference of color stimulus functions.

§ 32 "Chromaticity" in Science

The hues arranged on the hexagonal surface are called "chromaticities."

Seven basic colors are represented on the hexagonal surface in color fig. 12: the six chromatic basic colors at the six corners and the achromatic basic color white at the center. There are continual transitions between those seven basic colors. Through the quantity exchange of any two adjacent chromatic basic colors, we obtain the chromaticity hues (chromatic type hues) on the hexagon sides. Each of these chromaticity hues is then "mixed out" toward white.

We recall that the achromatic quantity of each individual hue on the hexagon surface is completely filled out by the achromatic basic color white. In other words: the hues on the hexagon surface have no portions of the achromatic basic color black. (This statement relates, of course, to ideal situations that cannot be completely implemented in printing.)

Hence, the common criterion for all hues on the ideal hexagon surface consists in having none of them blackened—in having none of them contain any component of the achromatic basic color black. This group of hues is referred to as "chromaticities" in color science [U]; they are arranged in the "CIE Chromaticity Diagram" in fig. 77. In this shoesole-like area we are dealing with the upper limiting plane of the cone-shaped CIE color space. The letters indicate roughly where the basic colors occur (after Neugebauer).

Compared to the color hexagon surface, the arrangement in the CIE Chromaticity Diagram is enormously distorted. Nevertheless, it is still an important form of illustration in colorimetry because it illustrates the point of departure for the mathematical recording of the CIE color space. Nor is this changed by the fact that this manner of illustration is not clear or distinct, that it is not suitable for explaining the various color mixing laws, and that is does not relate to the functional principle of the human visual system, which, after all, must be considered as the superior law of color theory.

It certainly makes sense to give this group of hues, which are represented by the hexagonal surface in color fig. 12, a special name. Of course, the concept of "chromaticities" appears to be problematical, to say the very least. It would be better to use this term only for what we called "chromatic type hues" because, on the one hand, after all, we are dealing here with mixtures of seven basic colors. On the other hand, it is difficult to see why the achromatic

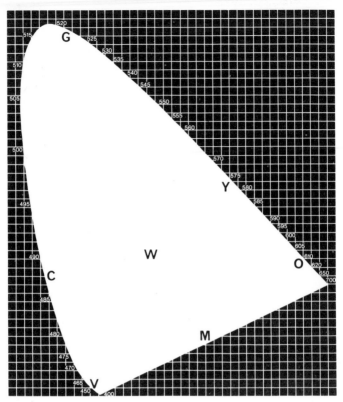

77 CIE chromaticity diagram showing locations of the basic colors (approximately after Neugebauer)

basic color white is supposed to be a "chromaticity" while the achromatic basic color black is not. It might be more precise to call these hues "unblackened hues" instead of "chromaticities."

We recall that the two-dimensional manner of arrangement on the hexagonal surface became possible because we decided to do without the achromatic dimension. This approach shows that we will again arrive at the totality of multiple colors if we mix every hue point on the hexagon surface in a continual series toward the point

black. Hence every point on the hexagon surface can be considered as the terminal point of a line whose other end is formed by the achromatic basic color black. If we now "tie together" all the black ends, we obtain the color space in fig. 78, with which we are already familiar (from fig. 39): a hexagonal pyramid standing on the black apex.

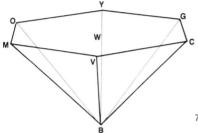

78 Once again for comparison: the hexagonal pyramid

These considerations, certainly, are interesting not only in theoretical terms. They also refer us to important practical interrelationships, to essential facts in our daily environment. This is because monochromatic objects normally reveal their three-dimensional shape because light and shadow effects arise on their isochromatic surfaces. Although the material has the same absorption properties in all places on the surface, it nevertheless is presented to the eye in the most varied hues, shadings, and degrees of blackening.

It is not difficult to understand this interrelationship. Depending upon the angle of the particular part of the surface of the object with respect to the eye and the angle of illumination, the qualitatively identical color stimulus reflected by the surface, reaches the eye with greater or lesser intensity. The three-dimensional modulation in the visual phenomenon of an isochromatic object is a "series of shadows" that materializes due to the degrees of blackening. (This of course applies only to dull surfaces without highlights resulting from reflection effects.)

Demonstration:
Fairly large sheets of dull colored paper
Cardboard rolls
Adhesive tape

The purpose of this experiment is to demonstrate how isochromatic sheets of paper show continual blackening steps by virtue of the illumination and observation circumstances alone.

Take rolls of cardboard, which can be obtained in a carpet store, or like those used for shipping purposes. Taking a sheet of colored paper cut to the proper size, first attach one side along the roll of cardboard with adhesive tape. Then firmly roll the paper around and glue the other end in place. Color fig. 19 shows various colored rolls prepared in this fashion.

Observe how the three-dimensional appearance of these rolls comes about. The continual shadow lines and transitions remain even if we turn the rolls. This clearly shows that they are not caused by the cylindrical surfaces, but rather by the existing illumination and observation conditions. It is also interesting in each case to compare a piece of colored paper that has been glued flat with the same hue on the roll.

Findings: Unblackened colored paper shows continuous blackening when rolled onto a cylinder. The three-dimensional effect of isochromatic objects comes about due to shadow formation. Reduced intensities of qualitatively identical color stimuli appear to be blackened.

Color Mixing Laws

§ 33 Additive Mixture (Color Television)

Additive mixture (AddMi) is a simultaneous cooperation of color stimuli on the retina.

One could refer to any kind of simultaneous mixture of color stimuli as an "additive mixture." If a person sitting under a blue parasol shines a flashlight on a white sheet of paper, that would actually be an additive mixture. This is because sunlight is altered by the blue material in terms of its spectral composition and is then mixed with the yellow light from the flashlight. Both types of light are superimposed; hence there is an addition of color stimuli.

In general, however, the term additive mixture (AddMi) should be understood as the principle of systematically remixing the multiplicity of colors from the colored lights V, G, and O by means of variation of intensities and reproducing the color space in this fashion (as well as this can be done with the available colors). This is actually the "classical" additive mixture. To avoid misunderstandings, we might specify that we always mean this "classical additive mixture" when we talk about AddMi.

Additive mixture is the technological attempt to simulate the way the visual system functions. To do this, we must have three suitable color stimuli that can cause the visual system to produce corresponding sensations. As a base, we must have the achromatic basic color black. This, for example, can be the darkness in a closed room. It is best to use three color lights, which should be constituted in spectral terms so that each activates the full (maximum) perception potential in one cone reception sector and so that if possible it will not activate any (minimal) potential in the other two.

Narrow-band interference filters [E] attached in front of three projectors [O] as described in the demonstration in Section 29, are particularly suitable. The perception of white results from the fact that all three types of cones are affected simultaneously.

Move the beams of light from the three projectors apart so that they partially overlap on the screen as shown in color fig. 22, so that all eight basic colors appear. The darkness of the room fills out the surrounding field as the basic color black. Where a colored light strikes the screen alone, we will see the basic colors violet-blue, green,, and orange-red. Where any two colored lights are superimposed, we get the basic colors yellow, magenta-red, and cyan-blue. Where all three of them are superimposed, we get the basic color white.

We find the technical application of the principle of AddMi in color television. Naturally, the achromatic basic color black is again the indispensable basis, which is present as the darkness in the television cabinet. Its purpose is to fill out the potential that has not been taken up. This is done the way air fills up the part of a bottle that is not occupied by liquids. Tiny phosphorus particles, in the colors violet-blue, green, and orange-red, are inserted into the picture tube's scanning disk and made to radiate. The radiation intensity is continually modulated for each of these three basic colors. In this way, the "color television reproduction system" becomes possible. The appearance of the individual hue comes about due to the corresponding values in the three reception sectors of the cone types, while the differential value, which remains open, is admixed as a portion of the achromatic basic color black.

Demonstration:
Colored paper in the basic colors V, G, and O [G]
Black paper
Prism [M] or [N]

Because it is possible to break down a white light ray into its spectral components by means of prism refraction, it must conversely also be possible to reproduce the remission of adjacent color samples by means of prism refraction on the retina in such a manner that they will be superimposed.

To do this, take a sheet of black paper. (Important: this experiment cannot be conducted with white paper because white reflects all visible radiations. Make sure to avoid any undesirable radiation here.) If

necessary, a sheet of carbon paper can be used; but be careful that it doesn't smudge the color sample.

Now take the sheets of colored paper, cut out rectangles, and place them on the black background as shown in color fig. 20. Examine this arrangement through a prism as illustrated in fig. 58. Due to AddMi, the colors Y, M and C (color fig. 21) arise along the borders. Of course, the resulting basic colors Y, M, and C do not appear as intensely as they do in the demonstration with the interference filters and the projectors. But the law of additive mixture can nevertheless be clearly demonstrated with these simple means.

You can even manage to bring about white with this principle of prism refraction if you arrange the colored paper cutouts as shown in fig. 79. It is recommended to glue the violet-blue and green pieces of paper firmly on the black sheet and to push the orange-red cutout with your left hand into the vicinity of the margin. At the same time look through the prism which you are holding in your right hand. You can rotate it easily in order to find the best angle while looking for the proper distance with your left hand.

Findings: AddMi is the technical attempt to simulate the way the visual system functions. This principle is the basis of color television. The basic additive colors are black, violet-blue, green and orange-red.

79 Seen through a prism, white results due to additive mixture (AddMi)

§ 34 Subtractive Mixture (Color Photography)

The term subtractive mixture (SubMi) designates the modulation of visible radiation energy through transparent filter layers.

Color mixing laws are possibilities for interpreting the laws of vision.

Subtractive mixture is the counterpart, the "reverse side," so to speak, the complementary law of additive mixture.

Here again we must first explain the concept. The generation of color due to subtraction occurs when something is "taken away" from the existing radiation energy by absorption. This would apply in this sense even, for example, if someone were to look at a snow-covered mountain landscape through sunglasses.

On the other hand, the term subtractive mixture is used in referring to that extreme principle in which the multiplicity of the color space is reproduced due to the absorption capacity of three series-connected filter layers. Here again one could speak of the "classical subtractive mixture." We want to make it quite clear that, in this book, we always mean this "classical" three-layer principle when we talk about subtractive mixture (SubMi).

Color photography (and in part multicolor printing as well) works according to the law of SubMi. The achromatic basic color white is always the indispensable initial basis for subtractive mixture. In color photography, it is present in the form of white light, which is necessary to see a color slide, either in projection or in front of a light box. In multicolor printing, the white paper surface provides this foundation.

The achromatic basic color white is absolutely necessary for the transparent color layers to display their absorption capacity. Such transparent color layers are also called "translucent." Basically, a transparent color layer is simply a color filter. In SubMi, we are dealing with color layers in the colors yellow, magenta-red and cyan-blue. These colors are also called subtractive basic colors.

Each individual color layer has the task of absorbing the radiation sector of one cone type. The full, optimum color layers, if at all possible, absorb all pertinent radiation. The yellow layer, for example, is supposed to allow no shortwave radiations through so that the reception sector for violet-blue will not receive a color stimulus and therefore no perception potential will be activated.

In reproduction systems that function according to the principle of SubMi, the color quantity in the color layer is individually varied for each picture point, that is to say, in each filter layer we can have a certain color quantity (i.e., between 0% and 100%). In each layer, the absorption volume corresponds to the existing color quantity. The greater the color quantity, the more of the particular radiation is absorbed and the less is allowed through. If no color quantity is present, everything is allowed to pass through in this radiation sector.

In this system, each of the three color layers thus has the task of modulating one perception power of the visual system. The perception power violet-blue is linked with the color layer yellow; the color layer magenta-red goes with the perception power green; and the color layer cyan-blue regulates the perception power orange-red. Depending upon the colorant quantity in the particular layer, more or less radiation energy falls on the related cones. All quantitative variations are possible here.

Demonstration:
Overhead projector
Filters in the colors Y, M, and C [V]

To demonstrate SubMi, first lay three filters in the colors yellow, magenta-red and cyan-blue next to each other on the overhead projector.

Each individual filter has the function of picking its own spectral sector out of the white light. This spectral sector corresponds to the reception sector of one cone type.

In other words, there are fixed relationships between these three filters and the three perception powers of the visual system. One filter is linked to each component. For example, the yellow filter absorbs the radiation sector that can activate the perception power violet-blue.

Now partially superimpose two filters at a time. Begin, for example, with the yellow and cyan-blue filters. Because the yellow filter absorbs the radiations that lead to the perception violet-blue and because the cyan-blue filter absorbs the radiation that allows the perception of orange-red to materialize, we can easily see why now only the green component is stimulated. The way in which the other filter combinations work emerges by analogy. This is why we need not specially go into every detail. In the filter combination of, for example, Y and M, only O is left, and in the combination of M and C, we get the color perception V.

Finally, place all three filters on top of each other in the arrangement shown in color fig. 23. Now we again have all eight basic colors, because such a reproduction system can function only if the missing basic colors materialize due to the cooperation of the initial colors.

The achromatic basic color white is the foundation. It is perceived where the light can pass unhindered through the disk of the overhead projector. But if the light goes through only one filter layer, we are dealing with the colors Y, M, and C. Wherever two filter layers are superimposed and thus cooperate in terms of their absorption possibilities, we get the colors V, G, and O. But no further radiation is allowed to pass through in the middle, where all three filters overlap. This is because the radiation sector in each filter layer that could activate the associated component is blocked. Because no color stimulus can strike the retina, we get the color perception black here.

Findings: Three filter layers cooperate in SubMi in terms of their capacity to absorb portions of white light. Color photography works according to this principle. The four subtractive basic colors are white, yellow, magenta-red and cyan-blue. Each filter layer has the task of modulating one perception power of the visual system.

§ 35 Colored Lights, Transparent and Opaque Object Colors
We must distinguish between colored lights and object colors, on the one hand, and between transparent and opaque colorants, on the other hand.

As we know, "color" is only a sensory perception. What we call "color mixing laws" are systematic concepts that have the purpose of causing the visual system to produce the desired color sensations. Color mixing laws thus always refer to the law of vision; they are interpretations of this law.

Just exactly how a color mixing law can take effect depends on the particular point on the chain of effects between light emission and the arrival of the color stimulus on the retina. The systematic concept of the color mixing law is governed by the link in this chain, in which we interfere through manipulation.

In the case of AddMi, for example, it is the radiation itself that strikes the eye and is modulated. This variation in the radiation intensity in the color stimulus is the most direct possibility of causing the visual system to allow the desired sensory perceptions to develop.

SubMi is one step further removed from the visual system, because the absorption performance of the three chromatic filter layers is the thing that works together in this case. Each individual filter layer has the task of modulating the radiation sector associated with a particular perception power (component).

Radiations that strike the eye directly are referred to as "colored light" or, if they appear achromatic, simply as "light." Naturally, colored lights can also strike the retina indirectly, as reflection from a white screen or a white wall. But basically in the case of "light" we are always dealing exclusively with radiation energy.

But if the chromatic appearance comes about by virtue of the fact that material (matter) absorbs visible radiation energy, then we speak of "object color." In contrast to colored light, object color can reveal the most varied properties. It can be transparent so that one can look through it; in this case it is "translucent." On the other hand, pigment can be nontransparent; in that case it is "opaque." All coloring agents are object colors, regardless of whether they are used industrially, in the crafts, or by artists, because we are always dealing with absorbing matter.

As we know, nothing is perfect. Just as there is neither absolute good, nor absolute evil, so there are in practical terms neither perfectly opaque, nor perfectly transparent object colors. Normally, every color material is somewhere between these extreme positions.

This makes the consistent implementation of color mixing laws much more difficult; the theoretical possibilities are restricted by practical inadequacies. In addition, we have the problem of the color intensity of coloring materials. Some derive their chromatic appearance from soluble coloring substances, others get it from pigments, in other words, tiny particles the size of grains of dust. It is to be hoped that industry will soon be successful in producing sets of mutually coordinated basic colors where not only the chromaticity (chromatic type hue) will be absolutely accurate but which will also, with regard to their color intensity and opacity,

correspond at least to the theoretical requirements in the manner in which this is already possible today with existing media.

Demonstration:
Various colors of matte paper
White illustration board
Various transparent and opaque coloring materials

The scope of this demonstration is to examine the covering capability of various coloring materials (paints). Use various kinds of coloring materials, such as tempera, India ink, and artist's oil paints. Mix the desired hues in little dishes. Now apply the same coloring materials on white and on black paper. Examine the degree of opacity. If the appearance of the colors on black paper has not changed as compared to their appearance on white paper, we have complete opacity. The greater the differences in terms of appearance, the less the opacity.

Now apply the same colors on colored paper. The appearance of opaque paints does not alter here either. But one can see through the transparent media and "view" the foundation. The absorption performance of the transparent color layer now cooperates with that of the foundation material. A transparent cyan-blue color layer, for example, looks green when applied to yellow paper.

Now examine the color intensity of various paints by mixing them together. Use identical quantities of different kinds of paints: oil paints, tempera, etc. Here again you might take yellow and cyan-blue as examples. All the oil paints presumably will reveal a whitened green as a result of the mixture; you will find the most varied results in the case of tempera, depending on whether you are dealing with dye paints or pigment paints. You might obtain a dark, vivid green when you combine a yellow pigment color with a cyan-blue dye color. This is because the dissolved cyan-blue dyes can come to rest around the individual yellow pigments like filters.

For an accurate evaluation of the mixing results, you must make sure that the thickness of the layer of paint applied is uniformly even.

Findings: Color mixing laws are possible interpretations of the law of vision. They can be implemented only to the extent that the available resources correspond to the theoretical requirements.

§ 36 Integrated Mixture (Achromatic Structure by Mixing Opaque Paints)

In integrated mixture (IntMi), the achromatic values basically result from portions of the achromatic basic colors white and black.

We are obviously dealing with a completely different mixing principle when we first mix the opaque paints and then apply them in a single color coat in such a manner that the color of the ground is covered up.

Let us remember: in the case of SubMi, three series-connected filter layers cooperate in terms of their absorption capacity. The differential value is added as a portion of the basic color white. In AddMi, on the other hand, the differential values are added as portions of the basic color black when three color lights, coordinated with the reception sectors, do not fully activate the sensation potential. Both mixing laws, subtractive mixture and additive mixture, however, do agree in that the four missing basic colors are produced due to the cooperation of the four existing basic colors.

Integrated mixture (IntMi), however, always pertains to only a single color layer. In this process, we basically mix first and apply later. It is therefore understandable that we need all eight basic colors for this type of mixture. Instead of a cooperation of the basic colors, we now have their quantitative exchange, which takes place in the manner explained in fig. 44 and illustrated in the numerical diagram in fig. 38 for the color hexagon. In the case of IntMi, the reproduction of the color space comes about because the achromatic value A of a hue can be filled out by every mixing ratio between white and black.

The single color layer with which we are dealing here is considered to be the mathematical quantity 1 = 100% and—in our computation system—corresponds to the 99 basic color quantity units of which a hue can be made up.

In those 99 quantitative units, however, we cannot have portions of all eight basic colors for one hue; instead, there is a strict law that prevails here that permits maximum portions of no more than four of them.

The achromatic basic colors white and black are always presented here because the achromatic values of the hues are

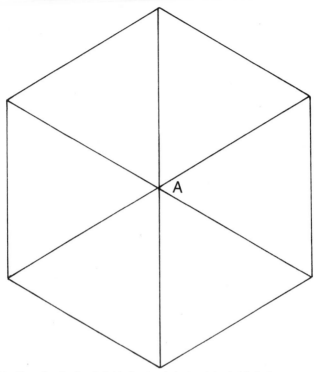

80 Three "apple slices" divide the rhombohedron into six tetrahedrons

basically built up from them. In addition, we can have portions of two chromatic basic colors which must lie next to each other on the color hexagon.

This is why in IntMi we can have only six groups of basic colors, portions of which can come together during the mixing of a hue. We find them in color fig. 24; only these combinations are possible. In each group, naturally, up to three portions can assume the value zero, so that the 99 quantitative units can come from one basic color or from two or three basic colors.

How these six groups come about becomes understandable if we clarify their geometrical interrelationships. We must visualize that the rhombohedron in fig. 30 is broken down into the six "apple slices" in fig. 80 by three axial cuts. In this way we get six

tetrahedrons as "subsystems," which we shall call "integrated tetrahedrons" (IntTe). The four possible portions in one mixture are now in each case taken from the four basic colors that have their places at the four corners of their integrated tetrahedron. In the subsystem of one integrated tetrahedron, the hue in this geometrical compartment can be mixed by means of the quantitative exchange of the four basic colors at the corners.

The law of IntMi enables us to arrive at various important insights. We realize that it is incorrect to believe that certain hues can be mixed only by means of refraction with countercolors. The precise mixing of the very finest hues is possible, according to the principle of IntMi, with considerably greater accuracy than with other methods. By building on the achromatic value and adding portions of a maximum of two neighboring chromatic basic colors, one can keep deviations to a minimum and can easily correct them. Because black color media are usually made of soot, mixtures using them can look "sooty." Where difficulties arise in this respect in the mixing of artist's colors, the special color "Leissner neutral dark" [R] can be used.

All of this is interesting not only for the artist, who could basically get along with eight tubes of paint and who attains the desired hues with greater accuracy. This is because the principle behind IntMi can readily be transposed to transparent media as well. Of course, in that case a white foundation must be available. But in return white is no longer necessary as a painting color, so that only seven tubes would be necessary.

IntMi can also be of the utmost interest in technical application. We can assume that the technologies of multicolor printing will be oriented according to these laws in the future. Since there is no alternative to the three-layer principle for color photography, a consistent achromatic structure would bring enormous technological and economic advantages to multicolor printing. The conclusion deriving from these considerations could even lead to a "super printing method" with seven printing inks that would strictly follow the integrated mixture. (Here again we are concerned with the eighth basic color. White would be represented by the white paper surface. [See Barron's *Color Atlas*.]) In this way, the purest and most luminous "pop" colors in the regions of violet-blue, green, and orange-red could be reproduced. For printing with opaque inks one could even work with phosphorescent colors.

Interesting aspects also emerge for other areas of industrial use, for example, for the lacquer industry or for textile dyeing. This is because so-called "trichromatic" dyeing systems fundamentally cannot produce any general solutions. In this case as well the complex problem necessarily resides in the color regions of violet-blue, green, and orange-red. The consistent application of IntMi would be more reliable, more interesting, and considerably more economical for this area of use as well.

Demonstration:
Barron's *Color Atlas* [L]
Artist's oil paints in the eight basic colors
Brushes

Practice IntMi through the remixing of hues. Select several color samples—material remnants, pieces of fabric, wrapping paper, or the like. The situation becomes particularly interesting when working with difficult hues, such as bottle-green, certain dark brown tints, or bright olive tints.

Now locate the nearest hues in the *Color Atlas* (in parts 1-3); determine which of the six groups this particular hue belongs to. Then begin mixing by making the gray shade that forms the achromatic value for the particular hue. Locate the required gray shade in the field in the upper left-hand corner of the chart in the *Color Atlas* where you found the hue. Now carefully add small amounts of the chromatic basic colors. Be careful not to go too far; this is why you should proceed in small steps and start with the chromatic basic color that is needed in the most clearly obvious manner for the chromaticity. If necessary, add the second chromatic basic color. Your best guide here is the attached color chart, which will help you to keep track of "where you are going."

These practical exercises on IntMi are very instructive because they confirm the theory even when the available paints are quite inadequate.

Findings: In IntMi, colors are mixed first and then applied in a layer. All eight basic colors are required for this type of mixing of opaque coloring materials. Achromatic values fundamentally result from portions of the achromatic basic colors white and black. Portions of two chromatic basic colors that lie next to each other on the color hexagon can be added. At most, four portions can be represented in one mixture.

Historical reference: The fact that there are eight basic colors had already been recognized by Leonardo da Vinci (1452-1519). He

refers to them in his *Treatise on Painting:* "After black and white come blue and yellow, then green, lion-colored or tawny, or if you wish, ochre, then the color of blackberries and red. These are the eight colors and there are no more in nature." (A. P. McMahon, *Treatise on Painting by Leonardo da Vinci,* [Princeton: Princeton University Press, 1956], Vol. I, pp. 83-84, paragraph 178.)

§ 37 Chromatic Mixture (Chromatic Structure by Mixing Opaque Paints)

In chromatic mixture (ChrMi), the achromatic values result from the fact that the chromatic basic colors neutralize each other.

In connection with IntMi we have already learned how the color space of the rhombohedron can be subdivided into independent parts or subsystems. The six "integrated tetrahedrons" resulted from the three axial cuttings.

We get three completely different subsystems if we "cut" the rhombohedron by means of two horizontal sections, as shown in color fig. 10 C. We are dealing with a fascinating geometrical situation because, in this way, the color space of the rhombohedron is broken down into three new geometrical solids, each of which is in itself absolutely symmetrical: one octahedron and two tetrahedrons. All outside surfaces of these three solids consist of equilateral triangles.

We might call the tetrahedron with the white tip the "white tetrahedron" and the one with the black tip the "black tetrahedron." The octahedron (color fig. 28 B) has eight outer surfaces, while each tetrahedron (color figs. 28 A and C) has four.

These three geometrical compartments again are three subsystems, each of which represents a new color mixing law, a law of its own. In the octahedron, we find materialized the uncompromising principle of chromatic mixture (ChrMi). The six chromatic basic colors are located at the six corners. There are three equal body axes, the "chromatic axes," which lead in each case from one corner through the geometrical solid's center to the opposite corner where the complementary color is situated. In the center, where they are all represented with equal portions, their chromaticity is

mutually canceled out. By mixing a hue, the largest common portion of the particular two complementary colors determines its achromatic value.

The most interesting aspect of the octahedron system is the fact that there are three different remixing possibilities for each hue in this color space, depending upon which two complementary colors brought about the achromatic values.

The basic colors W, Y, M, and C are at the four corners of the white tetrahedron. The basic colors B, V, G, and O are found at the corners of the black tetrahedron. All of the hues in one of these color compartments naturally can be remixed with portions of the four basic colors at the four corners of that subsystem. We might call the laws associated with the white tetrahedron and the black tetrahedron "white mixture" (WhiMi) and "black mixture" (BlMi).

In these two mixing principles, the achromatic values arise partially from the fact that chromatic basic colors neutralize each other and partially from the fact that portions of one achromatic basic color are also introduced into the mixtures.

The color compartments of subsystems could also be considered as "palettes," in the sense in which a painter uses this concept. The multiplicity of all hues is thus subdivided into clearly defined groups. Design exercises with such palettes produce unexpected insights.

Just like IntMi, WhiMi, ChrMi, and BlMi first of all relate to the quantitative exchange of opaque paints coordinated with each other in the previously described manner. Here again one can use transparent inks if a white foundation is available. But here again we always find applicable the principle that the points must first be mixed and then applied in a single color layer.

Demonstration:
Poster tempera paint set [W] or artist's oil paints
White drawing paper
Large sheet of cardboard or plywood

From the poster paints pick out the tubes that come closest to the eight basic colors (according to color fig. 24). Spread them on drawing paper, just as they are. Cut out equal rectangles and glue them on a large sheet of cardboard (or plywood), as in the middle in color fig. 25. This corresponds to the position of the basic colors at the corners of the rhombohedron (color fig. 10).

Using the basic colors white and black alone, now mix the gray shades of the scale on the left side in color fig. 25. Reading from top to bottom we are dealing with the following portions: W_{99}, $W_{83} B_{16}$, $W_{66} B_{33}$, $W_{50} B_{50}$, $W_{33} B_{66}$, $W_{16} B_{83}$, B_{99}. Cut rectangular pieces of equal size from these painted surfaces and glue them on a large piece of cardboard to form an achromatic scale. Do this in such a manner that every other painted field in the middle of the color fig. is on the same level with every other gray field.

Now start remixing the achromatic scale on the right side in color fig. 25 out of the eight basic colors, according to the principle of WhiMi, ChrMi, and BlMi. Because the available paints are only inadequately coordinated with respect to their coloring intensity and their absorption capacity, it is our goal in each case to adapt the appearance of the achromatic shades on the right scale to that on the left scale, so that you should not be bothered at all if some differences in brightness arise. The shades should be visually adapted to the neutral gray value to the extent that this is possible. This is not so easy to do when using tempera paints because one can judge the actual appearance of the mixture only after the coat of paint has dried. But you can improvise by using a fan for drying purposes.

Artist's oil paints do not entail these disadvantages. But on the one hand they are expensive and on the other hand we have to note that unfortunately it is very difficult to find these paints commercially available, even in the remotest approximation for the basic colors M and C.

First mix the basic colors in the middle of color fig. 25 on one level to form achromaticities and to obtain the corresponding shades on the scale on the right. White and black are taken over unchanged. The mixture of Y, M, and C leads us to the third field from the top, while the mixture of O, G, and V leads to the third one from the bottom. Finally, mix all six chromatic basic colors and you will obtain the gray that is exactly in the middle of the scale.

If the paints used met the theoretical requirements, this same medium gray would also result if equal portions of the color pairs Y and V or M and G or C and O were mixed. It is quite informative to conduct this experiment in order to clearly bring out the flaws inherent in the paints.

Finally, supplement the two missing shades. The white tetrahedron colors W, Y, M, and C give us the second field from the top; the black tetrahedron colors B, V, G, and O give us the second field from the bottom if we combine roughly equal quantities of them and mix them toward the desired achromaticities.

It is instructive to make an additional coat of the mixing results of the basic colors, O, G, and V, and, as in color fig. 26, to compare it to the mixture consisting of Y, M, and C: the detail picture (color fig. 27) clearly reveals an enormous difference in brightness. We should not be surprised at this if we look at the position of the chromatic basic colors in fig. 30. The associated achromatic shade must be found where the plane on which the pertinent basic colors are located intersects the gray axis.

Findings: The rhombohedron is subdivided into two tetrahedrons and one octahedron by two horizontal sections. The principles of WhiMi, ChrMi, and BlMi prevail in these component solids.

Historical Reference: Systems of arrangement in which the six chromatic basic colors are on the same plane (for example, Runge's sphere, Ostwald's double cone, or the CIE color space) are not suited for illustrating the higher law of vision and making color mixing laws understandable to students.

§ 38 Other Color Mixing Laws

On the whole, there are at least 11 color mixing laws. Although each of them strictly follows its own rules, we are in each case again dealing with a different possibility of interpreting the way the human visual system functions.

In the preceding chapters we have become acquainted with six color mixing laws—the six most important ones. The other five will be mentioned only briefly here in order not to make this book too long.

"*Gray mixture*" (GrMi) is a more differentiated form of the achromatic mix. The achromatic values here are no longer formed only by the two achromatic basic colors white and black. Instead, three so-called achromatic "auxiliary colors" are added: a bright gray, "light gray" (L), a medium grey, "neutral gray" (N), and a dark gray, "dark gray" (D). These three auxiliary colors have the mixing formulas $W_{75} B_{25}$, $W_{50} B_{50}$, and $W_{25} B_{75}$ (see fig. 46).

In the case of GrMi, we thus have five achromatic starting colorants, which assume the basic color functions. The rhombohedron color space is broken down into 16 "gray tetrahedrons" by these auxiliary colors. There is one auxiliary color at the apex of each of these pyramidal color compartments. There are three basic colors at the corners of each pyramid basal surface. In this fashion we get interesting new "palettes," that is, "gray palettes." The law of GrMi, for example, could be of special interest to the lacquer industry and to manufacturing techniques for textile dyeing as well.

"*Hue mixture*" (HuMi) describes the law that holds when any

desired hue is mixed with any other, as is done, for example, on a painter's palette. The possibilities of mixing any two hues are located on the straight connecting line between the geometrical points associated with them in the rhombohedron space. All mixtures that can be made from any three starting hues are located on the pertinent triangular surface in this color space.

The law of HuMi takes its course according to the principle of quantitative exchange. Each starting hue again introduces its portion into the mixture. But we are now no longer dealing with the portion of a basic color. Instead, each portion now represents a mixing ratio of various basic colors. This mixing ratio remains constant, regardless of the change in the size of the portion.

"Optical mixture" (OpMi) pertains to the "resolution capacity" of the retina. Details can no longer be perceived individually from a certain "smallness" onward. This is the case, for example, when yarns consisting of various fibers are woven together so that one can no longer recognize the individual threads from a certain distance. Multicolor screen printing is an important and at the same time interesting example of OpMi. In color fig. 29 the color appearance of the individual screen segments results from SubMi; they are located just below the threshold of recognition. This is why a magnifying glass that only magnifies five to ten times is sufficient for seeing the dot structures. The detail of color fig. 29 marked by the small white square is shown enlarged ten times in color fig. 30, where the fine screen (60 lines per centimeter) was enlarged to a gross screen (6 lines per centimeter).

Something which we can recognize only with the aid of a magnifying glass in color fig. 29, we can see with the naked eye in color fig. 30 by means of magnification: in three-color printing, there are screen segments in all eight basic colors. In screen printing these segments are perceived as a uniform hue because the eye's resolution capacity is not enough to identify them individually.

"Speed mixture" (SpMi) comes about by virtue of the fact that the visual system has a certain inertia. If individual color stimuli follow each other at very short intervals, they can no longer be recognized individually. This, by the way, is the only reason why the movies and television are at all possible as "dream factories." Here again the alternation of pictures is somewhat faster than the eye can identify individually. If varicolored color stimuli follow

each other at short intervals, each of them gives the visual system a "nudge" in its direction. The corresponding color sensations adjust themselves to the average values.

Whenever we are dealing with mixing laws where the paint must be mixed first and then applied in a coat, the results can be determined in advance by means of speed mixture, or the composition of the required portion can be analyzed on a rotating disk with the help of a sample by means of visual identity adjustment. Anyone who would like to take up SpMi in particular can use the outstanding (although also rather expensive) aids [Z] that have been devised for this purpose.

Finally, we should mention "*dye mixture*" (DyMi). It is always best when strongly dyeing concentrates are used to re-dye larger quantities of material. As an example we might visualize a house painter who, using liquid concentrates, mixes the white emulsion paint in his bucket in keeping with the wishes of the builder or the architect. This is a system in which the white emulsion paint is fundamentally used as a basic foundation and where the seven other basic colors are available as dye concentrates. According to the principle of IntMi, any desired hue could be easily mixed by means of the achromatic structure. The principle of GrMi could be used with even greater reliability; however the auxiliary colors would have to be available as concentrates. Because in wall painting one generally uses neither very pure nor very strong paints, one may also use a system in which, in addition to black, concentrates of only three chromatic basic colors are available, that is, concentrates of Y, M, and C.

Demonstration:
High-speed rotating disk
Paper disks in the eight basic colors [G]

Let us now demonstrate speed mixture. We need a high-speed disk with a clamping screw in the center. A skillful person can convert any ordinary room fan or power drill for this purpose, if it rotates fast enough.

One such homemade instrument can be seen in color fig. 31 A. The disk rotates like a turntable, but at very high speed. It should run fast enough for the two outer rings in fig. 81 to show the same medium gray. If it does not run fast enough, we get a flicker effect, which will make the mixing results appear much too bright. Undesired side effects (stroboscopic effects) can also result from light deriving from fluorescent bulbs, which is why this experiment should be performed only in daylight or by the light of an incandescent bulb.

In the middle of fig. 81 there is a segment subdivision that should be attached to the little disk with which the color paper surfaces are applied. This makes it possible to determine on the first try the size of the adjusted area sections.

As we can see in fig. 82, one circular surface is now cut out for each basic color and that surface is cut from the rim to the center. Depending upon the size of the clamping screw, now cut a hole around the center. Then insert the eight color disks in color fig. 31 B into each other in such a manner that you can "turn out" and adjust any desired segments between 0% and 100%. Place this "packet" on top of the thread of the screw, place the middle disk with the segment subdivision on top of it, and screw everything together firmly.

In color figs. 32 and 33 we can see, in each case, the segment adjustment on the left (A) and the result of the speed mixture on the right (B). In color

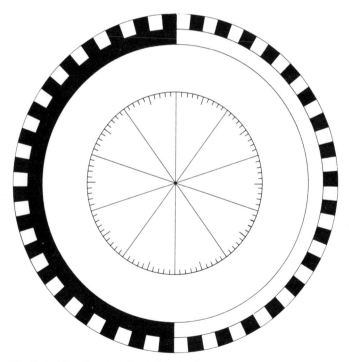

81 Control rings for adequate rotation speed

fig. 32, we selected an example of IntMi. The achromatic values here arise due to portions of white and black. In color fig. 33 we are dealing with an example of ChrMi. Here, the achromatic values result from the fact that the complementary colors neutralize each other. In this case, it is the corresponding portions of green and magenta-red that gives us the achromatic value to which we add the whitened mixture of yellow and cyan-blue.

With the rotating disk we can render visible the results of those mixing laws in which we are dealing with quantitative exchange; in other words, in addition to IntMi and ChrMi, we have WhiMi, BlMi, GrMi, and HuMi as well. This is because we must always consider the entire disk surface as the mathematical quantity 1 (i.e., 100%). The segments correspond to the color portions. By means of SpMi we can determine the appearance of the mixing result. This opens up interesting prospects, particularly when it comes to

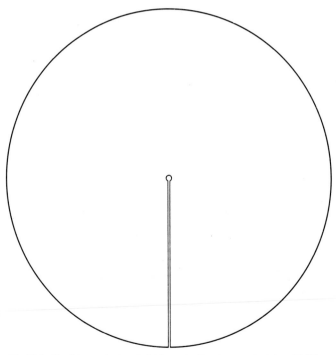

82 Disks like this can be inserted into each other for speed mixture (SpMi)

visually selecting the desired hues on the rotating disk and determining the mixing formula by reading off the quantity relationships.

Findings: Each of the 11 color mixing laws strictly obeys its own rules. Nevertheless, each individual law explains the law of vision, although from a different perspective. In practical application, different mixing laws are often in effect at the same time.

Color in Art and Design

§ 39 Quality Characteristics of a Hue

Chromaticity, achromaticity, achromatic value, and brightness are the four quality characteristics of a hue.

The so-called "quality characteristics" of hues are of special importance in art and design. By this we mean the parameters that relate to the appearance, to the visual phenomenon of hues. There are four such quality characteristics for each hue.

Hues can differ from each other in the way in which they are chromatic. We call this feature "chromaticity." A yellow color has a different chromaticity than a green one. The chromaticity of a red hue differs from that of a blue one. The various chromaticities are systematically arranged on the color hexagon in fig. 45. Chromaticities are chromatic basic colors or mixtures made up of two chromatic basic colors located next to each other on the color hexagon. Lines which, as in fig. 83, run from one point on the hexagon side to the center are "chromaticity lines." We find hues of identical chromaticity on these lines.

This interrelationship becomes clear in the quantitative diagram in fig. 84. The four squares at the bottom characterize the four possible portions of a hue. In our example, the quantitative ratio between the portions of M and O determines the chromaticity of this hue.

In the same diagram we see, on the left side, the portions of W and B. The quantitative ratio between them determines the quality characteristic of "achromaticity." We remember that all achromaticities are systematically arranged on the achromatic line (fig. 46). Because this dimension is missing in the color hexagon in color fig. 12, we cannot have any arrangement according to achromaticities on the hexagon surface.

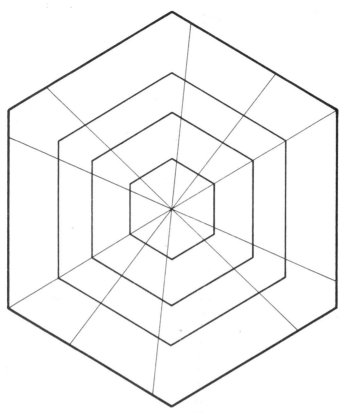

83　Chromaticity and achromatic value lines on the hexagon surface

In the quantitative diagram in fig. 84, the two portions of the two achromatic basic colors are combined in the achromatic quantity. The portions of the two chromatic basic colors, on the other hand, give us the chromatic quantity when they are combined. Our third quality characteristic is the "achromatic value," which represents the quantitative ratio between achromatic quantity and chromatic quantity. Because the achromatic value designates the extent of being achromatic, one can also call it the "achromatic degree" or "degree of achromaticness."

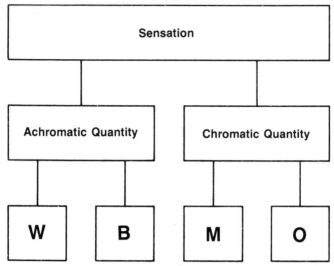

84 Quality characteristics are quantitative relationships between portions

The reciprocal element with respect to the achromatic quantity is the chromatic quantity. Achromatic quantity and chromatic quantity together always give us the mathematical value of 1 = 100%. This is why we can also consider this identical quantity ratio "from the other side," that is, from the side of the chromatic quantity. Thus we can also call this same quantity ratio the "chromatic value." If by the appearance of the hues we mean the extent of chromaticity, then we can also speak of the "chromatic degree" or "degree of chromaticness." We have already become acquainted in fig. 41 with the achromatic value arrangement on the surface of the color hexagon (color fig. 12). Lines running parallel to the hexagon sides are achromatic value lines, on which we find hues having the same achromatic value. But we could just as well designate them as chromatic value lines, since the hues on them have the same chromatic value as well.

The fourth quality characteristic is the "brightness" of a hue. By this parameter we exclusively and precisely mean the actual

brightness perception. Brightness is defined by that achromatic type hue that is perceived as equally bright. Because the eight basic colors have different brightnesses, each basic color portion introduces the brightness of its basic color into a mixture. The brightness of a hue therefore can be derived from the size of the existing portions and the associated individual basic color brightnesses.

In the visual evaluation of quality characteristics, we must not forget the influence of the spectral makeup of the existing light. We recall that the appearance of object colors depends on the existing light. Exacting visual experiments should therefore be performed at standard daylight. Where this is not possible, one should have common daylight available and should be aware that differences might appear. A pure violet-blue hue, for example, will look considerably darker and more impure in yellowish light than in white light.

Demonstration:
Color mobile [X]

Let us demonstrate the quality characteristics of hues by means of the "color mobile" [X]. This variable object, which can be seen in one of an infinite number of possible arrangements in color fig. 40, has a format of 88 × 88 cm and weighs about 10 kg. A silver magnetic plate is enclosed by an anthracite-colored wooden frame. It is designated "color mobile 75 rhombi, dark." (Unfortunately, this color mobile is not particularly inexpensive because of the great precision of its individual parts. Nevertheless, it will be carefully described here because it is particularly illustrative. But anyone willing to spend the necessary time can make a similar mobile with the help of a magnetic board and magnetic foil [C].)

The basic shape is the hexagonal surface in color fig. 34, which consists of 75 rhomboidal individual elements, each of which reveals four hues. The arrangement of the basic shape is the result of the strictly quantitative arrangements of the transparent color layers yellow, magenta-red and cyan-blue. Hence, this mobile is also an interesting demonstration of subtractive mixture.

In color fig. 35, only the outside row has remained. Here we have the systematic arrangement of the various chromaticities in the chromaticity hexagon (color hexagon).

On the other hand, in color fig. 36 we are dealing with an arrangement according to identical chromaticities.

Finally, in color figs. 37-39 we find arrangements according to achromatic values. The achromatic value in each case is largest in the middle, and decreases as we go to the top or bottom and from row to row. In the uppermost and in the lowest rows, the achromatic value has become 0. Hence, we find the hues with the greatest chromatic value there, i.e., the chromaticity hues from the outer sides of the hexagon (color fig. 34).

It is good practice, especially when working with students, to give them the corresponding elements already mixed and to ask them to put together the desired order according to the particular quality characteristics. Of course, one can also make an arrangement according to brightness. Because there would necessarily be shifts here in the printing process, we did not include such a figure. The exercises described here are easy to perform because the elements can be easily removed and their position easily changed.

The color mobile is constituted so that it can be used excellently both in classroom instruction and during seminars and lectures. A large group of people can easily follow the demonstration and can clearly see the results. No laborious preparations are necessary. Since each element is marked on the reverse side, the basic arrangement can readily be restored as a point of departure for new arrangements.

Findings: What we refer to and perceive as quality characteristics are in reality quantitative ratios of the basic color portions and the combined quantities of which a hue is made up.

Hint: Regarding quality characteristics, we find concept designations in literature and unfortunately frequently in education as well which differ from those used in this book and which lead to misunderstandings. Specifically we find the following:

instead of chromaticity: "chroma" or "hue" or "color tint";
instead of chromatic value or degree of chromaticness: "saturation" (if the relative share of the chromatic perception out of the total perception is meant) or "chromaticness";
instead of brightness: "luminance reference factor" or "gray step darkness" (*Dunkelstufe*), in connection with which these two concepts refer to certain systems.

To enable students to understand what teachers and authors really mean, it is suggested that the clear and unmistakable terms used here be generally adopted.

§ 40 Planned Color Effects

Color effects can be planned by systematically deriving the hue selection from arrangements in the color space or on the surface of the color hexagon.

As we know, there are people who are exceptionally musical and those who are noticeably unmusical. In a "normal" individual we may, however, assume an average musical sensitivity which at any rate in most cases should enable that person to learn how to play an instrument.

The situation seems to be similar when it comes to color perception. There are people with highly developed color tastes and others without any sense of color and color combinations at all. But most people have a "normal" color sense. Depending upon whether a person is concerned with color because of his job or his individual interests, his sense of color is developed to a greater or lesser degree. In one person, this talent may have shrivelled up whereas in another person it may be greatly sensitized. At any rate, it is to be assumed that every individual with "normal color sense" has the possibility of developing his individual color taste. Indeed, taste seems to be capable of being learned in this respect.

There are artists who handle color in a purely intuitive fashion; they exclusively follow their feelings and make the correct color decisions with great reliability in this manner. This is a totally valid personal principle.

The musically talented shepherd boy in the mountains whom we mentioned in the preface, can make highly qualified music on his homemade flute. But in a certain sense it will always be "naive music," because he only knows a portion of the virtually indeterminable possibilities that result from tones and intervals.

In handling color, there are certain analogies to the example of the shepherd boy. An artist who works in a purely emotional fashion naturally can very well develop his own individual trademark, as it were, his own inimitable personal style.

A color designer, on the other hand, could not display such a fundamental attitude; it is not his job to leave evidence of his personal taste everywhere. Instead, he must develop solutions according to objective criteria. Purely emotional color selections should cease at the very latest where art not linked to any specific purpose ceases. Wherever color composition pursues purposes and

the color selected will have a lasting effect on other people—people who cannot escape that effect—one must apply objective criteria.

There are colors that stimulate or even excite. There are others that cool off, calm down, or even tire. Every color-sensitive individual has a different individual relationship to colors. Color psychologists speak of "individual personality colors." These are colors that are "suitable" for the individual, that he prefers, to which he subscribes: "color identifies and commits." These are personal preference colors.

Obviously, these individually preferred colors are not matched up with the individual human being in a rigid and unalterable fashion. Instead, they are changeable; they can be influenced by many different factors. They can be sex-related and age-connected. They can also be fashioned by climate, tradition, and environment. They can even reflect the standard of living and the state of health of the individual concerned. Because colors are judged emotionally, that is to say, by the subconscious, the selection of preferred colors gives us a certain insight into the subconscious of the person making the choice. This is the basis for psychological color tests.

Proper color composition (designing) should take these interrelationships into account. Color composition for the private sphere of an individual should take into account the personality colors of the individual concerned. If a color composition is made for several persons, for example, for a married couple or a family, it is the task of the color composition expert to find the "common denominator." An apartment should be in keeping with the individual's taste and—where such taste has not yet been developed—the feelings of the inhabitants. In a restaurant, the owner's color feelings must of course be taken into consideration. However, in this case the color designer must also think of the "atmosphere" the restaurant patrons wish to find: comfort, warmth, and coziness, as the case may be. Color composition for the lobby of a hospital or city hall, or even the design of a building façade, an entire street or a city section presents very different problems. Here, entirely different viewpoints must prevail because such color compositions have an outside effect on the general public.

It is generally the objective of color composition to correctly select hues individually and functionally and to create balanced harmonies in the process. The problem of composition, of course, is that one must first see the specific hues in combination. In contrast

to acoustical sounds, the appearance of hues, as we know, changes due to the influence of surrounding colors and the spectral nature of the existing light. This means that what the hue will actually look like cannot be recognized from a sample, but only within the assembly represented by the overall composition.

Hence, color designers are always dependent not only on vision, but also on trying out certain effects. Unlike a musical composer, they cannot write down finished composition ideas with a black pencil. Color compositions, including artistic ones, are optimization processes—or at any rate they should be.

As in music, color effects are produced by "tones" (hues) and "intervals" (color intervals). Color harmonies are rhythms in the color intervals and in the surface area (area proportion) relationships. A color atlas can be an important orientation aid for the color composition expert or designer (for example, [L]). It displays not only the appearance of hues but also provides information on the relationships between them. It illustrates the common features that link hues, as well as the contrasts that create tension. Interesting effects located in one segment of the color space can be "transferred" into another segment. There are (unfortunately very expensive) color atlases [Y] where it is possible to take out the individual "chips" in order to study various possible combinations. Depending upon whether a color atlas is based on a quantitative or a qualitative principle of arrangement, one or the other group of interrelationships can be better recognized.

A color atlas is only supposed to provide suggestions and to lead to composition ideas. But in each case it is indispensable for the color designer to draft a color plan in which the selected hues are in the intended reciprocal relationships and in which the rough area proportions are already clear.

Demonstration:
Color mobile [X] (see Hint in Section 39)
Bright, white illumination

The previously described color mobile [X] is excellently suited for composition exercises. We will realize that color compositions that are based on a clear principle of arrangement are always felt to be "beautiful." The possible variations are infinite. We showed one example earlier (color fig. 40); this is one possible solution which generally is felt to be particularly

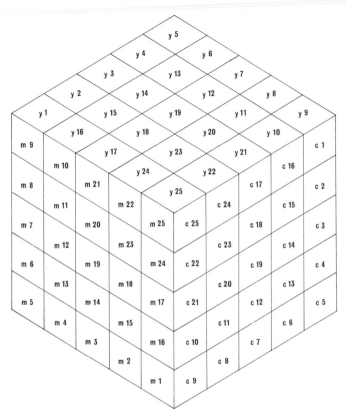

85 Numerical diagram of the basic arrangement of the color mobile

charming and harmoniously balanced. Such composition exercises obviously constitute a rather demanding task, because we are dealing here with nothing less than "taming" the "concentrated charge" of the color hexagon. This can be done in a purely intuitive and emotional manner, just as it can be done by implementing a previously well thought out arrangement.

The individual chips are marked on the reverse side. Fig. 85 shows the basic arrangement with which it is best to begin. Color developments or principles of orderly arrangement that one wishes to implement can be

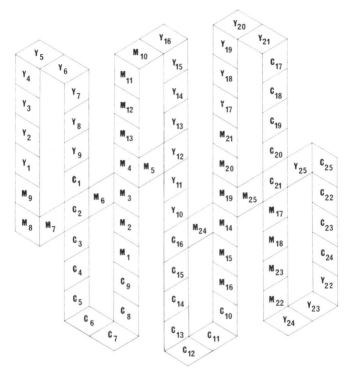

86 Numerical diagram of the composition exercise in color fig. 40

"read" from the basic arrangement (color fig. 34) and written down in so-called "numerical images." In fig. 86 we find the numerical diagram for the composition involved in our example (color fig. 40). Naturally, both approaches are possible: you can first compose in a visual fashion and then note down the numerical image, or you can first record a principle of orderly arrangement in a numerical image and then make the arrangement on the magnetic board and study the effects.

There are a wealth of other possibilities for conducting composition exercises with the color mobile. For example, you can place all 75 elements on a well-lighted table and then give the assignment of selecting

combinations that correspond to certain moods, that associate certain experiences or sensory perceptions, or that, for example, reflect the seasons of the year. The rhombi, as we can see in color fig. 41, can be arranged with three, four, or five chips, or in any desired rows. Naturally, other geometrical arrangements are also possible.

By marking the particular rhombus fields in the numerical image of the basic form (fig. 85), one can analyze how the color effects arise, what constitutes the connecting and separating factors, what the common features and the contrasts consist of. We can recognize both quantitative and qualitative relationships. The intervals and their rhythms become visible.

It is also very interesting in the above-described experimental arrangement to let each person participating, one after the other, select his individual perferential colors and to present the results (whose code numbers should be recorded) to the entire group and to discuss them. The assignment might be this: everybody must present the same number in the same geometrical order or the number and arrangement can be selected freely.

Findings: Color effects result from quantitative and qualitative relations between hues. Harmonies can come about through common features or contrasts. In the final analysis, we are always dealing with the rhythm that develops due to surface area proportions or intervals between the hues.

§ 41 Environmental Responsibility of Color Designers and Architects

Incorrectly used colors can lead to annoyances comparable to those deriving from sound (noise), odors (stench), or lighting (blinding).

Obviously, the work of a color designer can be regulated by law just as little as the operating techniques of a surgeon or the question of which spices a gourmet chef should use can. The color designer must act according to his own sense of duty and in keeping with the

criterion of his own knowledge and discretion. His activities will always be fashioned by his own taste and his own esthetic sense as well.

But a color designer cannot and should not be allowed to do just anything. In contrast to the artist, he must, when it comes to compositions that will have an effect in public, display consideration for the "normal esthetic sense of the people." But who is authorized to draw a dividing line between what is permitted and what is forbidden? Are not the judges of an administrative court being overburdened when they are supposed to render a verdict as to whether they should allow the petition of the conservationists, according to whose opinion the color composition of a concrete architectural project in Göppingen County "increases the contrast between the building and the surrounding landscape to the point of ugliness" and must therefore be removed? Indeed, the Mannheim judges sentenced the building owner to remove the artistic façade design, which exerted its effect through powerful color accents, and to replace it with a "subdued color" (*Stuttgarter Nachrichten,* April 6, 1977). These judges based their verdict on "the sensations of an observer who is open to esthetic impressions but is not particularly sensitive or trained."

While the artist needs to follow only the judgment of his taste, the color designer is a problem solver because nobody can avoid the effects of public color composition. These effects can be quite considerable on the individual. In the negative case it can lead from the creation of a bad mood via discomfort or nausea all the way to vomiting in very rare cases.

There are countries, including West Germany, where building owners are not allowed to build "any old way." Construction permit applications must be submitted to and approved by the appropriate authorities. In West Germany, external color composition for buildings is basically included in a construction undertaking that is subject to mandatory permits. Only in the case of building renovations is it permitted to restore the prior façade design without renewing the original license.

But in practice the situation often turns out differently. People paint their homes the way they like or the way the painter recommends. One really cannot see why an employee in a construction office should be more competent to decide as to whether a planned color design fits harmoniously into an overall

environment than the seasoned painter, who acts not only for the building owner or builder but who must also make sure that his work will be appreciated by the public.

Color figs. 41-47 are examples of the environmental significance of color composition in architecture. First of all, in color fig. 42 we find the typical example of "noncomposition." This farmhouse in the Spanish village of Alcala de Chivert can be termed "composed" neither from the architectural viewpoint nor from the angle of color selection. It is actually nothing but a shelter, a roof over one's head. Architecture and colors quite naturally derive from the available materials. However, harmonious nuances can arise which, in spite of the lack of planning (or precisely because of it), offer a particular esthetic charm.

In color fig. 43 we are again dealing with a "noncomposition." This is the result of a solution to a specific problem: the largest volume of living space had to be created with the available money. There was obviously no money left over for esthetic "frills." This suburb of Barcelona has taken the place of slums; its success was measured by the number of people housed under decent conditions. Such apartments in most cases are purely utilitarian structures and result from the assembly of prefabricated elements based on the building block principle.

In contrast, in color fig. 44 we are dealing with an architecturally "deliberate" design solution. This gigantic building complex in Kranichstein, near Darmstadt, is arranged in a rhythmically interesting fashion. The association of the individual building masses with each other and the ratio between the volumes can—considering the problem that had to be solved here—be termed bearable, perhaps even "somewhat appealing." The monotony of the rows of windows might be considered rather sterile. It is difficult to see what the architects and the builders were thinking of in connection with the color composition: there is no reason whatsoever to emphasize disproportionately large building masses by means of a white coat of paint and contrasting them against the sky in a most striking manner by means of the yellow trim. Wouldn't it be better in such cases to provide pleasing nuances among the building masses that harmoniously fit into the multicolored appearance of the surrounding natural elements? This is an example of how architecture can become an alien body in a natural setting due to color composition.

In color fig. 45 we see a renovated façade that any "normal" observer would call "beautiful" or "in good taste." The front of the building is harmoniously dominated by a dark and a light olive green. The light gray of the natural stone ornaments and the white of the windows accentuate the color tone. A cold red was quite aptly placed on the coats of arms as a color accent. The golden garlands enhance the "smart" appearance. Indeed, we get the feeling that this house in Mannheim is a "jewel" in a rather monotonous row of houses.

The situation becomes difficult, to be sure, when the owners of buildings along a street compete with each other in terms of the color compositon of the façades. This can lead to color situations that will make every passerby happy, but it can also "flop." An example of this, which some people consider particularly charming but which others perhaps will reject as "too colorful" or even "cheap," is shown in color fig. 46. Isn't the previously mentioned "sensation of an observer receptive to esthetic impressions but not particularly sensitive or trained" somewhat disturbed here?

A clearly negative example of color composition in architecture is presented in color fig. 47. This "house of colors" is located at the exit to the town of Tarragona, Spain. The effect on a color-sensitive individual can only be termed "brutal." The observer is really "clobbered." What a horrible idea to have to live in a city where all the houses are painted like this. Even gray would be better; at least it doesn't insult anybody. This kind of house undoubtedly constitutes "environmental pollution;" people feel bothered by it. For some people, it is a "public nuisance." For the sake of the human community one must prevent color from being publicly handled in this thoughtless fashion.

Demonstration:
Trip through a city
Evaluation of façade color composition (if possible: photograph interesting buildings for future discussion)

A field trip through the city is extremely worthwhile in terms of taste training and the development of the ability to make judgments. You should look at both old and new façades. Analyze the hues used; check out the effects and compare.

You will find that, next to the rather modest looking houses there are those that, structurally speaking, are in a good condition. But they do not

stand out, nor do they disturb anybody. Then again you will encounter color compositions that appeal to the observer. In rarer cases one will be quite enthused. And then comes the point where "opinions differ." Borderline cases, which some people might consider "daring," will perhaps be judged "unbearable" by others. Finally, there will be compositions that are met with general rejection.

If you photograph interesting buildings, you can calmly analyze and discuss them at home. You will find that an individual hue as a façade color, in combination with white trim or white windows, usually creates no problems at all. Frequently it is possible to combine two harmonizing hues. As a rule, the uncertainty, the "fiasco," begins with a third color. The colors begin to "snap at each other," to compete with each other in an unpleasant manner or to appear strange next to each other. In general we can say that a façade in which three (or more) chromatic hues cooperate harmoniously is composed in a skillful manner.

The most frequently encountered mistake consists in the fact that excessively strong hues are selected for large surface areas. Achromatic colors are very significant for color composition in architecture, especially in continuous rows of houses. The eye obviously requires achromatic interruptions as "pauses." Where these are absent, compositions can easily create a "mottled" effect in the negative sense.

Findings: A good designer should not leave behind "monuments" to his own personal taste. Instead, he should be a problem solver who uses color in a functionally correct fashion and who finds the individual preference colors for those concerned.

Supply Sources

To make it easier for the reader to carry out the demonstrations and experiments described in this book, we would like to provide some references regarding sources of supply. We hope they will serve as an aid in obtaining suitable equipment, materials, or the like. For each case of practical application, reference was made to only one source of supply used by the author. In many cases, it is representative of other suppliers who also have suitable equipment and materials in their sales catalogs, although the author did not test them.

[A]
Polaroid polarization filter foils:
Polaroid Corporation
Technology Square 545
Cambridge, Massachusetts 02139

[B]
The Sylvania fluorescent lamps used had the following designations:
homelight deluxe IF
warmlight deluxe WWX
coolwhite deluxe CWX
daylight D

[C]
Magnetic boards and magnetic foils:
Magnetic Aids
488 Madison Avenue
New York, New York 10022

[D]
The Pantone matching system numbers given here are from:
Pantone Inc.
55 Knickerbocker Road
Moonachie, New Jersey 07074

Paper sheets from Pantone by Letraset can be used. Make sure beforehand, however, that the hues of the sheets agree exactly with the specified numbers of the Pantone matching system since discrepancies unfortunately occur.

Yellow: Pantone 102
Orange-red: Pantone 137
Magenta-red: Pantone 225
Green: Pantone 354
Cyan-blue: Pantone 313

[E]
Interference filters with a gap of about 20 nm can be obtained from:
Scott Optical Glass Inc.
York Avenue
Pittston, PA 18642

The average wavelengths are:
448 nm for violet-blue
518 nm for green
617 nm for orange-red

These filters are also suitable for the demonstration of the "classical additive mixture."

[F]
Pantone hues corresponding to [D]:
Violet-blue: Pantone 266
Green: Pantone 354
Orange-red: Pantone 165
Yellow: Pantone 102
Magenta-red: Pantone 225
Cyan-blue: Pantone 313

[G]
Supplier as indicated in [D]:
Violet-blue: Pantone 266
Green: Pantone 354
Orange-red: Pantone 102
Magenta-red: Pantone 225
Cyan-blue: Pantone 313

[H]
Such continuous-tone films can be obtained from lithographic or blockmaking companies.

[I]
Cut-outs to paste together rhombohedrons, octahedrons, white tetrahedrons, and black tetrahedrons are available on the jacket of *Farbe—Ursprung, Systematik, Anwendung [Color: Origins, Systems, Uses]* by Harald Küppers [Kueppers], Georg D. W. Callwey Edition, Streitfeldstr. 35, 8000 Munich 80, West Germany, 3rd edition, 1977.

[K]
All-purpose glue, such as "Elmer's."

[L]
Color Atlas, by Harald Kueppers, Barron's Educational Series, Inc., 113 Crossways Park Drive, Woodbury, New York, 1982.

[M]
Klinger Scientific Corporation
110–20 Jamaica Avenue
Richmond Hill, New York 11418

[N]
H. O. Proskauer
Amselweg 9
CH-4143 Dornach bei Basel (Switzerland)

[O]
"Prado Universal" projectors (5 × 5 cm)
E. Leitz, Inc.
Rockleigh, New Jersey 07647

[P]
Interference filters corresponding to [E], but with the following average wavelengths:
469 nm
587 nm
428 nm
569 nm
492 nm
627 nm

[Q]
Plan DIN 6169, part 8, August 1976, *Farbwiedergabe [Color Reproduction];* Plan DIN 6173, sheet 2, March 1973, *Farbabmusterung [Color Matching]* through: Beuth-Vertrieb GmbH, 1000 Berlin 30.

[R]
"Leissner-Neutral—Dunkel" (without black) poster tempera color type 25:
H. Schmincke & Co.
GmbH & Co. KG
Otto-Hahn Strasse 2
4006 Erkrath
West Germany

[S]
Recording spectral photometer: the first instrument of this kind was developed by Hardy and was made and sold by General Electric. Later the Diano Corporation took over production and sales. In addition, there are the following instruments, among others: DMC 25 colorimetry instrument by Zeiss (Oberkochen, West Germany); Spectronic 505 spectral-photometer by Bausch & Lomb (U.S.A.); HRS 4001 spectralphotometer by SEM Brückl (Munich, West Germany); Trilac spectralphotometer by Kollmorgen (U.S.A.).

[T]
Filter photometers working with interference filters, for example: RFC 3 filter colorimetry instrument by Zeiss (Oberkochen, West Germany); Datacolor spectralphotometer, Datacolor (Dietlikon/Zürich, Switzerland); FS 3 A spectromat by Pretema (Birmensdorf/Zürich, Switzerland); KCS 18 Color Eye (automatic) by Kollmorgen (U.S.A.).

[U]
Same as [Q] but DIN 5033, part 1, plan of November 1977, page 3, column 1.

[V]
Same as [E] but standard filter set for the colors yellow, magenta-red, and cyan-blue for demonstration of subtractive mixture.

[W]
Poster tempera, "Pelikan":
#59d Cadmium Lemon
#51 Saturn Red
#43 Purple
#120 Ultramarine Deep
#123 Cerulean Blue
#160 Cinnabar Green Deep
#02 White
#013 Lamp Black
Koh-I-Noor Rapidograph, Inc.
100 North Street
Bloomsburg, New Jersey 08804
Or selections from "Pelikan" "K 12" or "K 18" varieties.

[X]
Color mobile of 75 rhombi is available in an 88 × 88 cm format from:
Harald Kueppers
Im Buchenhain 1
6070 Langen
West Germany

[Y]
Some color atlases with removable chips:
Munsell Book of Color
Macbeth Color and Photometry Division
Kollmorgen Corporation
Newburgh, New York
Color Harmony Manual, according to Wilhelm Ostwald
Container Corporation of America
Chicago, Illinois
Uniform Color Scales
Optical Society of America
2000 L Street N.W.
Washington, DC 20036

[Z]
Case with demonstration materials for "speed mixture" on rotating disk; two gyroscopes with battery-operated motors and the most varied colored disks:
System Polyton, based on an idea by André Lemonnier:
Sociétée Polyton SA
20, Bd Princesse Charlotte
Monte Carlo
Monaco

[Z 1]
Color theory teaching charts:
H. Schmincke & Co.
GmbH & Co. KG
Otto-Hahn-Strasse 2
4006 Erkrath
West Germany

[Z 2]
Functional model of vision:
Harald Kueppers
Im Buchenhain 1
6070 Langen
West Germany

[Z 3]
Set of eight basic color paints available from:
H. Schmincke & Co.
GmbH & Co. KG
Otto-Hahn-Strasse 2
4006 Erkrath
West Germany
Order numbers:
15190 W system-white
15209 Y system-yellow
15320 M system-magenta
15430 C system-cyan
15319 O system-orange-red
15670 G system-green
15479 V system-violet-blue
15787 S system-black

[Z 4]
Küppers' [Kueppers] color mixing course coloring book.
Format: 24 x 34 cm [about 9½″ x 13½″],
16 pages:
H. Schmincke & Co.
GmbH & Co. KG
Otto-Hahn-Strasse 2
4006 Erkrath
West Germany

Illustration Credits

Figs. 50, 51: Federal Institute for the Testing of Materials (BAM), Berlin

Color figs. 44-46: Caparol. Deutsche Amphibolinwerke Robert Murjahn. 6105 Ober-Rahmstadt. Farb-Studio

Color figs. 10 A and B, 22, 23; Figs. 48, 53: From Harald Küppers [Kueppers], *Farbe—Ursprung, Systematik, Anwendung.* Georg D. W. Callwey Edition, Munich, Third Enlarged Edition, 1977

Figs. 17, 25-30, 34-41, 43, 44, 77, 78, 81-84: From Harald Küppers [Kueppers], *Die Logik der Farbe. Theoretische Grundlagen der Farbenlehre.* Callwey Publishers, Munich, 1976

Color fig. 12: From Harald Kueppers, *Color Atlas: A Practical Guide for Color Mixing.* Barron's Educational Series, Inc., Woodbury, New York, 1981

The other figures were supplied by the author.

Selected Bibliography

The following books have been selected and recommended by the author to amplify related topics or to go into greater detail on the subject matter:

Billmeyer, Fred W., and Saltzmann, Max. Principles of Color Technology. *New York: John Wiley & Sons, 1966.*

Format *21.5 x 28.5 cm, 181 pages, 133 illustrations including 2 in color, 127 references grouped by subject.*

Meticulously describes the connection between vision and colorimetry. Several color-order systems are explained. Of interest especially to the producer of colorants and paints and to industrial color appliers. Requires some prior technical and mathematical knowledge.

Birren, Faber. Color Perception in Art. *New York: Van Nostrand Reinhold, 1976.*

Format *21 x 21 cm, 86 pages, 23 black and white and 12 color illustrations.*

Begins with the history of nineteenth- and twentieth-century color expression. The parallel history of color theory is covered. The importance of illumination is considered. New concepts for color expression in art are presented. Esthetic implications are the subject of the last section. An interesting book for designers and colorists.

Birren, Faber. Principles of Color. *New York: Van Nostrand Reinhold, 1969.*

Format *21 x 21 cm, 96 pages, 56 black and white and 8 color illustrations.*

Basically, this book deals with the history and importance of the color circle. It describes how a color triangle is formed for each hue of the color circle by matching with black and white. Harmony rules for color presentation are derived for both the color circle and the color triangle. Color presentation effect is considered at the end. The book is a clearly organized and easily understandable introduction to the basic rules of color presentation.

Evans, Ralph M. An Introduction to Color. *New York: John Wiley & Sons, 1948.*

Format *19 x 24.8 cm, 340 pages, 310 illustrations including 15 in color, large number of references.*

Begins with an introduction to the optical and physical area of color, and explains its relation to the perceptual process. Illumination and colorimetry are considered in detail. The mixing behavior of color lights and object colors is described from a colorimetrist's point of view, in which reference to technical application plays an important role. This book is an interesting and detailed presentation of the basic facts, especially for scientists and technicians. Although it is a very practical book, prior mathematical knowledge is required.

Fabri, Ralph. Color: A Complete Guide for Artists. *New York: Watson–Guptil; London: Pitman, 1967.*

Format *22.2 x 28.2 cm, 176 pages, 25 black and white and 48 color illustrations.*

Written by an artist for artists. A brief introduction covers the history of the use of color and the definition of terms. The effects of color are presented systematically and the meaning of colors is explained. Presentation rules and possibilities of color expression are explained through the examples of successful paintings. The last chapter deals with the question, "Is color a medium of self-expression?"

Goethe, Johann Wolfgang von. Theory of Colors. *Cambridge: M.I.T. Press, 1970.*

Format *13 x 20.2 cm, paperback, 423 pages, 7 illustrations including 6 in color.*

Those especially interested in the history of color theory may also want to concern themselves with Goethe. This book gives them a good opportunity to do so, for it provides in translation Goethe's essential observations on color. With an introduction by Deane B. Judd.

Inter-Society Color Council. Color-Matching Aptitude Test. *Philadelphia: Federation of Societies for Coatings Technology, 1978.*

A practical test that evaluates color sensation. The person being tested with this system has to place colored chips by judging visual equality. The test results give not only the kind of color weakness or blindness, but also the degree of abnormality.

Itten, Johannes. The Art of Color. *New York: Van Nostrand Reinhold, 1973.*

Format *29 x 31 cm, 156 pages, 202 color illustrations.*

Dealing with the subjective experience and objective rationale of color, this book develops a theory of esthetic color and analyzes its use by the masters. The numerous color illustrations are essential to understanding the text. Itten's theory is considered to be an introduction to the rules of color designing. It has earned an international reputation in art education.

Judd, Deane B., and Wyszecki, Günter. Color in Business, Science and Industry. *New York, London: John Wiley & Sons, 1967.*

Format *15.3 x 23.5 cm, 500 pages, 123 black and white illustrations, 25 pages of references.*

In principle, this book is an extraordinarily detailed and carefully substantiated introduction to colorimetry. It begins with a description of visual processes and ends with the chapter "Color Harmony." It stresses the optical and physical area of color. Hence,

this book will be especially worthwhile for colorimetry in industrial and technical color applications. It was written by a colorimetrist for specialists; prior advanced knowledge, especially in mathematics, is required.

Küppers [Kueppers], Harald. Farbe—Ursprung, Systematik, Anwendung, *3rd ed. Munich: Georg D. W. Callwey Edition, 1977. (The English translation,* Color: Origin, Systems, Uses, *published in New York by Van Nostrand Reinhold in 1973, is out of print at this time.)*

Format *22.5 x 27 cm, 196 pages, 102 illustrations including 85 in full-page color, bibliography.*

This book was awarded a bronze medal at the International Art Book Exhibition in 1977. It has been translated into the major Western languages and the third revised edition of it has already been published in Germany. This is a color theory in which the reader gets to see what is said in color. The color illustrations are of excellent quality, produced in seven-color printing. A straightforward didactic conception leads from the physical and physiological aspects of color to systematic color sequences and finally to color mixing laws. This is not a theoretical/scientific, but a visual/practical, an educational introduction to color theory.

Küppers [Kueppers], Harald. Die Logik der Farbe. Theoretische Grundlagen der Farbenlehre. [The Logic of Color: Theoretical Principles of Color Theory]. *Munich: Callwey Verlag, 1976.*

Format *22.5 x 27 cm, 176 pages, 258 illustrations including 12 in full-page color.*

The author's new theory is described in great detail in this book (not yet available in translation). According to his theory, all forms of color origination, mixture, and perception must be explained through the function of the visual system. The author calls his rhombohedron system the "ideal color space," for from it he explains all the existing qualitative and quantitative relationships between hues. Eleven color mixing laws are defined in a mathematically and geometrically precise manner. Quality attri-

214

butes of hues are given quantitative explanations. This leads to the quantitative interpretation of color harmonies. No prior academic knowledge is required. This is a book for those who are "advanced" in color theory.

Munsell, Albert H. A Grammar of Color. *New York: Van Nostrand Reinhold, 1969.*

Format *21 x 21 cm, 96 pages, 47 black and white illustrations, 8 color pages.*

The system of organization developed by the artist Munsell in 1898 is explained here with an introduction by Faber Birren. It is based on the principle of equidistant perception. The quality characteristics are designated as "hue, value and chroma." This "oldtimer's system" has retained its importance until today for those concerned with esthetics and the visual classification of colors.

Optical Society of America, Committee on Colorimetry. The Science of Color. *Washington, DC: Optical Society of America, 1973.*

Format *18 x 25.2 cm, 385 pages, 102 black and white figures, 25 color plates, 623 references.*

No fewer than 23 well known authors have made contributions in their areas of specialization. The essential details of a color theory—from a physical point of view—have been collected in this volume with scrupulous scientific accuracy. Starting with a historical background, the book covers the physical and physiological facts, several classification systems, and colorimetry. Prior knowledge of mathematics and optics is necessary, which leaves open to question the claim that the book is intended not only for scientists and students, but also for manufacturers and artists. Just as incomprehensible is how a work that is so physically oriented can claim to be "the definitive book on color," since color is nothing other than sensory perception.

Sargent, Walter. The Enjoyment and Use of Color. *New York: Dover Publications, 1964.*

Format *13.5 x 20.2 cm, paperback, 274 pages, 36 illustrations including 7 in color.*

The author, a landscape artist and teacher, intends to teach the reader how to appreciate the sensory experience of color. In doing so, simple basic rules of color science are also considered. It is a textbook on color for art departments of secondary schools and a book for general reading as well.

Wright, W. D. The Rays Are Not Coloured. *London: Adam Hilger, 1967.*

Format *13.5 x 19 cm, 154 pages, 7 illustrations including 3 in color, 88 bibliographic references.*

This little book consists of nine essays that summarize the author's lectures. Each essay is a complete topic in itself. Examples: "Towards a Philosophy of Colour," "Television and the Visual Process," "A Course of Colour for Schools," or "Modern Problems in Colorimetry." Worthwhile reading for those interested in color and color theory. One learns, for example, that Newton wrote: "For the rays to speak properly are not coloured. In them there is nothing else than a certain power and disposition to stir up a sensation of this or that colour."

INDEX

Italic page numbers indicate material in illustrations